Roses
for the Pacific Northwest

for the
Pacific Northwest

Christine Allen

STELLER
press limited

Published by
Steller Press
1 - 4335 West 10th Ave.
Vancouver,
British Columbia
V6R 2H6

Photography by Christine Allen and Michael Kluckner
other photo acknowledgements on page 162
Author photo by Steve Paton
Design: Paul Thomas, Thomas Design, Victoria
Illustrations by Moira Carlson

Printed in Canada

Canadian Cataloguing in Publication Data
Allen, Christine
Roses for the Pacific Northwest

Includes index
ISBN 1-894143-02-7

1. Rose culture - Northwest, Pacific I. Title

SB411.A54 1999 635.9'33734'09795 C98-901446-0

For Michael

I can pass to you
Generations of roses in this wrinkled berry.
There: now you hold in your hand a race
Of summer gardens...

Christopher Fry
"The Lady's Not For Burning"

CONTENTS

INTRODUCTION

Sooner or later every gardener comes around to roses. Of all the flowers in all the gardens of the world, roses seem to exercise the greatest powers of attraction while at the same time generating the greatest apprehension and fear of failure. Some experts believe that the lure of its perfume has kept the rose on the list of most desired garden plants; some think it is the beauty of the flower; others believe the long and romantic history of rose culture is its most significant feature. Whichever it is, and I think all three have some influence, my purpose in writing this book is to encourage the attraction and attempt to reduce the apprehension.

I have come to believe that the most important element in the enjoyment of growing roses is to choose the varieties most likely to relish the climate and soil conditions where you live. In my corner of the world, the temperate coast of the Pacific Northwest region of the North American continent, that means roses which are content in short, mild summers, cool, rainy winters and heavy, slightly acid soil. They are not always the same roses that thrive in New York or California, New Zealand or England, the parts of the world that seem to have generated the vast majority of books about rose-growing. Nor are they, for the most part, roses that can survive the cold winters of inland regions of the Northwest without protection of some kind. If they are particularly hardy, I have mentioned it in the description, but gardeners who contend with harsh winter weather should plant their roses deeper than recommended for coastal conditions and hill them up with earth or mulch in fall.

My own love affair with roses began when we bought a dilapidated old Vancouver house with a beautiful cottage garden. It was obvious from the start that the house needed restoration, and we were prepared for that, but it took some time before it dawned on us that the garden would also need attention if it was to remain as lovely as it looked on the day we closed the sale. One of us had to become a gardener-and the role fell to me. There were a lot of roses in the beds, both at the front and back of the house roses I now know were Hybrid Teas and Floribundas. Some were healthy and vigorous, but others

seemed to have a magnetic attraction for insects and assorted spots and fungi.

I started by reading everything I could find on the subject, and followed up by joining my local rose society (where I had to unlearn some of what I had read because it didn't apply in Vancouver). I watched others pruning roses and then tried my hand at it. Some of my roses sulked none of my sources had told me that 'Peace' doesn't like to be pruned as hard as other Hybrid Teas. I learned about combatting disease and took the recommended action. Some of my roses refused to respond found out that 'Tropicana' will break out in spots in our climate, no matter how well I tend it. But some roses rewarded my attention realized that 'Queen Elizabeth' is so widely planted because it is so forgiving of ignorant gardeners like me, and that 'Madame Alfred Carrière' will make the best of any situation, however scant the soil or the sunshine.

Gradually, I began to make changes. I fell in love with a picture of the old Centifolia rose 'Fantin Latour' and added one to the garden. It grew into a larger bush than I expected, and covered itself in fragrant, pink flowers every summer. One year, I entered a bloom in a rose show and it won a first prize. I wanted more of these big, summer-flowering beauties, and suddenly my garden, which had seemed so vast, so full of unknown plants, so daunting, began to look, well, small. So we moved - to nine country acres of sheep and cow pasture on a gentle south-facing slope. The existing garden was a narrow strip along the front of the house, filled with sweet william and a few other perennials, but mostly with the roots of some enormous Lawson cypresses. The rest was coarse grass and dandelions. Not a single rose.

We began slowly. I laid black plastic down in a long, curving strip on the slope below the house. The following year, we dug and tilled the heavy clay soil, and amended it with rotted manure (which we found in a huge pile behind the barn). By this time I had learned how to raise shrub roses from cuttings and, thanks to a generous friend with a vast collection of Old Garden Roses, I had a tiny collection of my own. The size of these baby plants deceived me into planting them much too close together in the new bed, and over the next few years a number of them had to be moved elsewhere as the fragrant

hedge I had dreamed of gradually filled out and became a reality.

Since the spring of 1992 when we arrived here, the garden has extended to cover nearly an acre of land. Among a random assortment of annuals, perennials and vines there are almost two hundred roses, most of them Old Garden Roses, and I am well on the way to achieving my ambition of covering all of the surrounding fences with massive ramblers. What began as a necessity sixteen years ago has become an obsession. Since roses have given me so much pleasure, it saddens me when I hear someone say they have given up on roses because they are too finicky, too time-consuming or too sickly. Perhaps if I can share what I have learned along the way - what my city garden taught me about modern roses, and what my country garden has revealed to me about old ones - it will encourage someone who has stopped growing roses to start again, and inspire someone who has never grown a rose to plant one.

CHOOSING A ROSE

I never planned to be a gardener. I was going to be one of the new breed of career women who worked till the pension kicked in. Then we bought an old house in the city, partly for the pretty cottage garden surrounding it. The roses in that garden were beautiful enough to distract us from the fact that the place needed a new roof and hadn't been painted since Moses was a boy, but they weren't going to stay that way unless one of us learned how to care for them. It was not a question of me making a garden; rather, over a period of years, that garden made me.

Almost all gardeners are impetuous souls. In spite of the warnings of landscape designers and owners of famous gardens who attribute their success to careful planning, most of us are waylaid and seduced by a variety of plants as we make our way through the aisles of the local garden centre. All the same, a little background information can help you better understand the roses you have already bought, and will with any luck come to the surface of your mind the next time that you are drawn to make a purchase.

Grafted vs. own-root

The first consideration is whether you should opt for a plant that is growing on its own roots or one that has been grafted (budded) onto the root system, or understock, of a more vigorous variety. Not so long ago, gardeners didn't have the luxury of this choice: virtually all commercial rosebushes were grafted onto understock. By far the greater number of them still are, and there are good reasons for this, both for the producer and the purchaser. From the producer's point of view, a grafted rose is more economical to produce: a single bud from an existing rosebush is spliced onto each understock, and a skilled operator can do this at a rapid rate. With modern methods, the producer can expect close to a 100% success rate. A grafted rose is also swift to reach maturity. Since the understock is usually a two-year old plant, the roots are already well-developed and

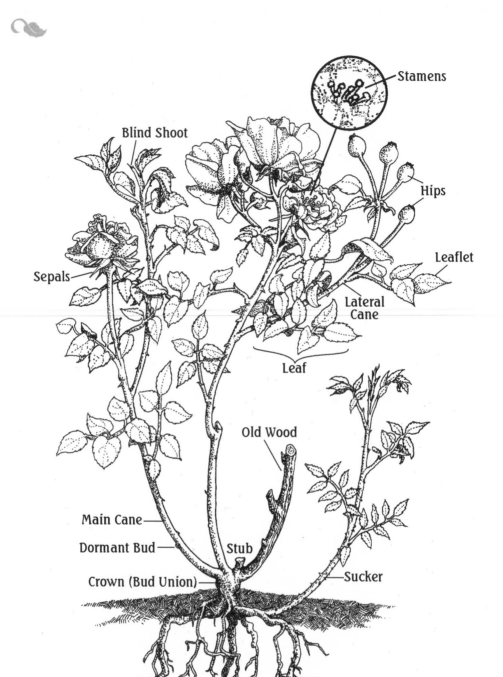

Stamens

Blind Shoot

Hips

Leaflet

Sepals

Lateral
Cane

Leaf

Old Wood

Main Cane

Dormant Bud

Stub

Crown (Bud Union)

Sucker

will generate a sizeable amount of stem and leaf in a very short time. Customers who buy a grafted plant in spring can reasonably expect a healthy crop of blooms the same summer.

Many modern roses actually need the support of a root system from a wilder, stronger variety. The energy required to produce flowers continually for several months is beyond the ability of their own much weaker root systems to sustain. In fact, many modern roses will not last a winter on their own roots; or, if they do, will struggle along as sickly, undersized plants no matter how much loving care they receive.

On the down side, there is always the possibility that shoots from the understock roots will begin to grow and these suckers will compete with the growth of the grafted variety. Another risk, especially during cold, frosty winters, is that all growth dies back to ground level. Unless the bud union (the point where the original graft was made) is protected by heaped-up soil, or some kind of free-draining mulch, all that remains alive is the root system, which again is not the same as the rose you bought.

There is also evidence to suggest that different roses go dormant at different rates in the fall. Here in the Pacific Northwest, we need our roses to be dormant before the winter frosts begin. A plant that struggles to produce fresh growth as the weather grows colder will exhaust itself trying, and any growth that does succeed in emerging will be too weak and soft to survive until spring. For example 'Dr. Huey', a rootstock favoured by California growers has a reputation for going dormant later than Rosa multiflora, the number one choice of Canadian companies, which have to contend with a much longer and harsher period of cold weather. Rosa canina inermis - a thornless version of the dog rose - goes dormant even earlier, which makes it a good understock in areas with short summers, although it has a tendency to produce suckers.

In recent years, an increasing number of nurseries have begun to offer "own-root" roses for sale. Most of these are the old-fashioned shrub roses, climbers and ramblers which have root systems vigorous enough to support their growth. In fact, most roses used as understocks for grafted roses are climbers or ramblers, which have roots capable of sustaining their own tall, sometimes immense, growth.

For the commercial grower, it is more difficult to make a profit with these own-root roses. Each begins as a cutting which is planted and tended until it generates its own roots. Cuttings usually consist of stems with four dormant buds (compared to the one required for each new grafted plant), so more wood is required to produce the same quantity of plants. There is also a much greater risk of failure: some cuttings begin roots, then unaccountably wither; some die when they are transplanted; and some never form roots at all. Even when they are successful, these little cuttings take time to develop a large enough root system to support much growth, so plants tend to be very small in their first year, and generally take three years to reach the size that a grafted rose will achieve in one. However, own-root roses excel in a couple of ways. They are naturally hardy as there is no graft to provide a potential weak spot for frost or disease to attack. As long as the roots survive, what returns as new growth will always be the variety you planted. Although they take longer to mature, they are exceptionally long-lived, and are much less likely to suffer from mosaic virus or crown gall, two debilitating diseases which have been an ongoing problem for rose-growers, particularly in the United States.

To my mind, they develop into more shapely bushes because the canes are not confined to a central point as they are on a grafted bush, but spread naturally as the roots extend. (In a few cases, notably the moss roses, the plants may spread too far and invade surrounding territory, but most roses are well-behaved and rarely encroach on neighbouring plants.) More widespread growth at the base means that these roses rarely suffer from "wind-rock" in sites exposed to the elements. When a plant generates all its growth from a central point, the action of the wind can easily loosen its grip on the soil, and as it rocks back and forth, it scours a hole around the base that frost and ice can fill and quite likely freeze the plant to death.

While there are fierce debates among professional rose-growers as to which method is superior, the difference should matter little to most gardeners, provided that they understand the effect on the plant they buy and, if it is an own-root plant, are patient with its slower growth to maturity.

Modern or Old?

The vast majority of roses in today's gardens are modern hybrids, introduced during the twentieth century. They typically have large flowers with 20 to 35 heavy petals which form a pointed bud and open slowly around a centre circle of golden stamens. The canes are thick, the thorns large and spaced at intervals along the stems. Leaves tend to be large, leathery and dark green. Bushes are upright with most leaf and flower production in the top two-thirds, creating a clean look at soil level. These roses dislike root competition from other plants and are often grown evenly spaced in a bed of their own, although they can, with care, be blended into a mixed garden bed.

Modern hybrids also come in a wide range of colours, from soft pastels to vivid reds and oranges. Most producers have focused on breeding for size and colour, with the result that many otherwise good roses lack fragrance. Nonetheless, there are some very strongly scented modern roses available. With their emphasis on thick petals and long stems, modern roses have also become favourites of flower arrangers. Ask anyone to describe their first mental image of "the rose" and, nine times out of ten, it will be the tightly furled bud of a florist's bouquet. The most significant feature of modern roses, however, is their ability to bloom throughout the summer and well into fall, and it is this characteristic that has made them so very popular with gardeners.

Old Garden Roses, on the other hand, usually bloom for an average of four to five weeks of the year, and although in this time they put forth the same number of flowers that a modern rose takes a whole season to produce, their short-lived beauty has made them poor cousins to the latter in the minds of many gardeners. However, there is a growing body of gardeners, myself included, who value these fleeting blooms for their delicacy and generous profusion, and for more subtle characteristics such as their wide variation of leaf size and shape, the fall colour that many of them display, and the vivid hips in assorted shapes, sizes and colours that adorn their bare branches in winter. That said, the colour range of flowers among these old varieties is limited - white, and all shades of pink, crimson and violet, although there are a few nineteenth and

twentieth century ones with flowers in gentle shades of lemon and apricot.

As a rule, Old Garden Roses are less susceptible to disease than modern ones. They grow into larger bushes well-clothed with leaves, many with an arching habit so that their flower-laden branches often sweep the ground around them. Although most varieties are heavily protected by prickles, ranging from the furry-looking stems of moss roses to the vicious hooked thorns of ramblers, a few have no thorns at all. In the Old Garden Rose category, rambler roses have a special place, being vigorous enough to clamber high into trees or cover wide sections of fences or walls.

Unlike Hybrid Teas and Floribundas, Old Garden varieties, once established, are quite capable of competing for space with other plants, and are often used in mixed perennial borders or in wilder surroundings such as among shrubs and in grass. A number of the more vigorous varieties are also able to tolerate more shade than most roses and still give a satisfactory amount of flowers.

The flowers themselves range from the simple five petals (or in one instance only four) of wild roses to the "hundred" petals of the centifolia roses, so popular with painters of the eighteenth century. They may be flat rosettes made up of many short, frilly petals, or globular flowers with petals folded like Japanese origami paper patterns. Most are fragrant, although the strength of their scent varies with weather conditions and time of day.

A growing number of new introductions, usually referred to by the catch-all title of shrub roses, are attempting to combine the best traits of both modern and antique roses. Best known are David Austin's English roses, bred for an old-fashioned look and scent but with the same long-blooming attributes and range of colour found in modern hybrids. As with all roses new to the market, it will be some time before there is enough knowledge about their overall performance to determine how they measure up to roses with proven track records. Some of those which have met with general approval are listed in Chapter 2 under Shrub Roses.

Bare-root or container grown

The way a rose arrives on your doorstep depends on where you got it from. If you picked it up at the local supermarket, it was probably packaged in damp sawdust in a plastic bag inside a cardboard box with its picture on the outside. This is not the best way to obtain a rose. Even if it was a good specimen originally, the chances of it drying out in transit or in the heated warehouse of the store make it a risky purchase. In all fairness, I have known people who have had some success with this kind of package. Not many, though. Roses marketed this way have often had their canes coated with wax to protect them in transit. Do not attempt to remove this coating when you plant the rose; it will gradually break and peel off of its own accord, and the rose will be none the worse for the experience.

If you bought your rosebush from a nursery in spring, as most people do, it will come in a pot of reasonable size, at least 2 gallons and hopefully more. It may have been ordered in fall and grown on in the pot over the winter, or it may have arrived bare-root from a wholesaler the week before you purchased it. You will know as soon as you try to remove it from the pot. If the soil falls away from around the roots, it has obviously been recently potted. This is not a bad thing - some plants potted up in the fall rapidly develop vigorous roots and soon become potbound, strangling new growth with old; others suffer from exposure to freezing temperatures during winter and never fully recover. If you suspect the latter, find an opportunity to whip the pot off and have a look at the roots before you buy. A healthy plant should have evidence of new young white roots sprouting from the older growth. If all looks brown or, worse, black, don't buy the plant no matter how much green growth there is above ground. Roses have enough residual nutrients in their canes to keep the tips growing for some time after the roots have died.

The vast majority of nurseries on the West Coast purchase their stock in early spring, and wise gardeners try to be among the first to buy. This way they get the best selection, and the possibility of a rosebush which is to all intents and purposes a still dormant, bare-root plant.

When you are deciding which of these packaged or potted roses to buy, look for one with at least three good, thick,

healthy canes - the industry standard for a #1 rose. Fewer canes mean a lower-grade plant, which may not develop into a vigorous bush. (This advice is strictly for grafted roses; if you are buying a young, own-root plant, it is more likely to have only one or two thin, wiry stems, and as long as these look green and healthy, it is probably just fine.) If you buy early in the season, don't expect the roses to have leafed out, but do look for evidence of leaf buds about to break from good fresh stems, and for live roots when you remove it from the pot.

If you follow the example of really serious rosarians, you will order your plants in late summer from the catalogue of a reputable grower, and receive them as bare-root plants in October or November. Not only do you get a much wider choice of varieties this way, but you usually get strong, healthy plants.

However, there are a couple of precautions to take when obtaining your roses this way, and I can't stress them too strongly. The first is to pay for express delivery service if you are ordering from a grower on the other side of the continent. In the fine print of the guarantee you will inevitably find a sentence which absolves the grower of any responsibility for your plants after they leave his hands. Horror stories abound of unheated trucks parked overnight on the frozen wastes of the prairies while their fragile cargo succumbs to the cold. The unlucky purchaser is left with a parcel of dead roses and no means of redress.

The other is to waste no time unpacking your roses and plunging them into buckets of cool water for several hours or overnight. The longer you delay this process, the more you risk the future health and vigour of the plants. Even though most come carefully packed in damp fibrous material, they will be suffering from some degree of desiccation and will be in urgent need of water. A good soak in water is the preliminary step to successful planting of all bare-root roses.

Roses with Drawbacks

Climate has such an effect on some classes of roses that the chances of them doing as well here as they do in, say, California, are slim. In particular, roses with many petals of thin substance, such as the Bourbon group, are frequently a disappointment because the buds fail to open in rainy weather, becoming sticky balls of brown mush before falling to the ground. It's a pity because the Bourbons are among the most beautiful and fragrant of roses, besides having the characteristic of blooming in both summer and fall. Reports from England, where it drizzles but rarely pours, and the drier areas of the U.S always describe these roses in glowing prose, so it is easy to be seduced into planting them here. Of course, if you live on one of the coastal islands where the climate is drier than on the mainland, you have more likelihood of success with such fragile flowers. Not so in the rainshadow of the Cascade mountains! I kept a plant of 'Boule de Neige' for three years before I faced up to the fact that it had succeeded in opening only one (admittedly glorious) bloom per year, and turfed it out.

Some roses are simply too tender to endure even the relatively mild coastal winter this far north. Roses with a lot of China parentage are more likely to succumb, including the Banksia group and many of the Noisette ramblers, such as 'Lamarque', which always looks so beautiful in publications coming out of the southern states. Even if the plant survives and thrives, the output of flowers can be disappointingly meagre.

Among modern roses, a number which have done extremely well elsewhere don't seem to adapt happily to our conditions. 'Just Joey', one of the world's favourite roses with its ruffled blooms of soft apricot, is notoriously disappointing for Northwest gardeners. "Grow it," says one of my knowledgeable colleagues, "as an annual, and be grateful if you get two years from it." Another rose much recommended in other parts of the country but often less satisfactory here is the red climber 'Don Juan', which grows well enough but needs a longer summer than we can guarantee to encourage a good display of bloom.

These are just a few examples of roses which get rave reviews in other parts of the world but don't always live up to them in the Pacific Northwest. Take a chance on them by all means - there's an exception to every rule and you might be the lucky one - but by the same token be prepared for disappointment.

A Formal Rose Garden or Mixed Borders

The style of garden you have in mind should influence the type of roses you choose.

Hybrid Tea roses and Floribundas have thick, rigid canes which grow naturally upright. With proper pruning, they will mature into vase-shaped bushes with most flowers and foliage in the top two thirds of the plant, leaving rather bare stems around the base. This neat habit makes them the ideal candidates for a formal layout, where each rose can display its flowers to advantage.

Careful spacing has the additional benefit of giving each plant the room it needs to thrive, since this type of rose is jealous of its territory and does not like to share root space with other plants, including other roses. Allow 60 cm. (24 in.) between bushes. This suits their nutrient requirements, gives you room to move around them when pruning or weeding, and contributes to the geometric design which make these formal beds look good. If you plant in staggered rows, beginning the first row 45 cm. (18 in.) from the edge of the bed, you can fit three rows into a bed 2 metres (6 1/2 ft.) wide. It is traditional to edge formal beds with low boxwood hedges, but keeping the box meticulously trimmed is very time-consuming. Lavender and santolina are alternatives: they also require clipping, but you can get away with doing it twice a year, once in spring and once after blooming. Some gardeners prefer to clip santolina before the blooming season, as the yellow flowers can clash horribly with certain roses. Decorative brick borders are a maintenance-free option.

Formal gardens look best when each bed is planted with either the same rose, or ones in similar colours. This works well in public gardens but does not allow much scope to the homeowner who would like to have a range of colours. A good compromise is to settle for either hot colours or pastels to give the planting some unity.

Roses in mixed, informal garden settings can be of any type, although Hybrid Teas and Floribundas need careful placement if they are to thrive, because of their need for their own space. Modern shrub roses or Old Garden Roses, being less demanding, are better choices for mixing in with other plants, although even

they should be protected from competition during their first year at least. It is a misconception that all shrub roses are large plants that will dominate a border; some like 'The Fairy', 'Rose de Rescht' or 'Fair Bianca' are of a modest size quite suitable for the front of a bed. There are also a number of small-sized bushes, often described as "patio roses", which are ideal choices for a small garden.

Old Garden Roses are naturals for inclusion in mixed borders where their habit of blooming for no more than four to five weeks is no drawback among other plants with similar characteristics. In bloom they put on a magnificent show, and before and after their great moment they provide good green furniture to complement spring and fall flowers. Some varieties, such as Rosa glauca with its blue and plum coloured leaves, are valued as much for their leaves as their flowers. Many of these roses have arching canes which enhance the soft, romantic look of a country-style garden, and can be trained against a fence like small climbers.

Even though shrub and antique roses are more willing to share space with other plants, it's a good idea not to challenge them with neighbours that have a tendency to spread. The best companions are plants with a compact root system of their own. Bulbs are ideal, and lilies and roses are long-time friends in the mixed border. Hostas spread wide leaves which keep the soil moist for the roses while benefiting in turn from their shade. Foxgloves make tall accents and blend well with old-fashioned rose colours, but keep their fibrous roots tucked beneath their own foliage. 'Lady's Mantle' (Alchemilla mollis) is another traditional companion, although you have to cut off the flowers before they go to seed if you don't want to be extracting myriads of tiny plants from under the roses the following year. Lavender, delphiniums, monkshoods, carnations - even ornamental grasses - keep to themselves and yet blend well. Most of these are traditional combinations, but there's no reason to confine yourself to them. Just plan to keep rampant spreaders at a respectful distance.

TYPES OF ROSES
and Best of the Bunch for the Pacific Northwest.

Every year I promise myself that this has got to stop: "No more new roses, " I tell myself sternly. But then there was the opportunity to acquire a plant of `Francis E. Lester', a rambler I'd always wanted. I spent the next day digging up a large ornamental kiwi and replanting it at the other end of the garden, so that I could move another rose, 'Phyllis Bide', into the vacated space, thus freeing the perfect position for 'Francis'. Once I would have been embarrassed by my lack of advance planning, but I now know that this is normal behaviour among gardeners.

Of the thousands of named roses available today, how do you choose a suitable specimen for your garden? It is tempting to take a short cut by visiting the nearest garden centre, looking at the labels, and picking one that looks pretty. Of course, all the labels look pretty, and none of the descriptions ever mentions the dread word disease. An unlucky choice could put you off roses for the rest of your gardening days, which would be a pity since there is a rose, even more than one, that will prove immensely satisfying to you. More painstaking gardeners will read up on the subject, maybe even consult the American Rose Society's Handbook of Roses which rates roses registered in the U.S.on a scale of 1 to 10. A rose with a rating of 8 or above is considered an excellent variety. But there are pitfalls there, too. Many of the reports on which the ratings are based come from states like California and Texas and roses that have performed well in those climates do not necessarily thrive in our cooler, cloudier gardens, and heavier soil. Another concern, which is particularly relevant to Hybrid Tea and Floribunda roses, is that certain ones which have been around for a long time seem to degenerate decade by decade, and what began as a much-hailed variety loses its original vigour. This appears to be happening with 'Peace', the best-known and most-loved rose in the world. Why this happens is something of a mystery, but the theory is that, if you clone a rose time and again over a long period of time, which is, in effect, what the production process

does, then eventually those plants farthest down the line will be diluted versions of the original.

The descriptions below include roses in every class that have been satisfying additions to the gardens of rose enthusiasts in the Pacific Northwest, with some details of their growth habits and their resistance to disease. Some do have drawbacks, and these are mentioned, along with the mitigating factors such as a strong fragrance that justify their inclusion. Some which are relatively new on the market are recommended for their good early performance, although their staying power is as yet unproven. The date of introduction which follows each listing is a valuable guide in this respect; roses that have remained in commerce over several decades have obviously earned widespread approval.

Not all of these roses are widely available, but if the demand is there, perhaps they will become so, and this will be all to the good for Pacific Northwest gardeners.

The chapter after this one suggests which of these roses are suitable for particular purposes, and includes some additional varieties which are outstanding in these circumstances.

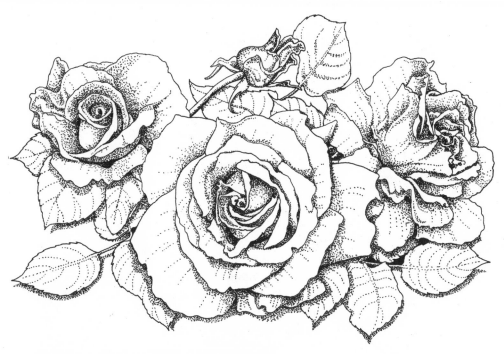

HYBRID TEAS (Large-flowered Roses)

It is little more than a hundred years since the first Hybrid Tea roses were introduced into commerce. In that relatively short time they have succeeded in becoming the world's most popular class of rose, and the one most people think of when asked to visualize "a rose". This undoubtedly has a lot to do with their dominance of the cut-flower industry. A characteristic garden specimen is a strong, angular, fairly upright plant with large flowers on long stems and large, glossy, dark green leaves. The flowers come in a wide range of colours from white through all shades of pink and lavender to red, yellow, apricot and bright orange. There is generally one flower to a stem, although a central flower with two side buds is not uncommon.

The flower shape is usually a central cone with the outside petals opening out evenly to form a star shape or a perfect circle.The petals themselves usually number between 20 and 40, although a few older varieties mentioned have single blooms with just five petals each. In general, petals are thick and pearly, which means that the flowers last well when cut. Fragrance ranges from strong to virtually none. An emphasis for

many years on breeding for size and colour of the individual flower, combined with a determination by some companies to release as many new varieties as possible per year, has resulted in vast numbers of Hybrid Teas being introduced over a relatively short period of time, with little regard for their health or hardiness. Fortunately, most of them have gone as quickly as they came, with much less fanfare, but even some of those with good reputations find our climate too cold or too wet, or our summer too short for their liking. The varieties listed below have all earned approval in the Pacific Northwest - primarily for their performance in the garden but in many cases also as cut flowers for the house.

In areas away from the moderating influence of the Pacific Ocean, roses need a sheltered spot and preferably some form of winter protection. Be prepared for growth above the soil surface to die in below-freezing temperatures; if you have protected the bud union and the roots, new growth will emerge in spring. It is not unusual for the rootstock to survive, even though the graft has not. When this happens, you will know by the different appearance of the new growth, and eventually by the flower which will be nothing like your chosen variety. A few Hybrid Teas have the strength to make good plants on their own roots and these may be worth seeking out if you live in a cold zone.

(Note: U.S. companies have an irritating habit of changing the names of European-bred roses to improve their "consumer appeal." Canadian companies generally adhere to the original name. Where this is an issue, pseudonyms are listed in the index.)

Alexander (1960)

A tall-growing plant which can be trained as a climber, `Alexander' has flowers of an eye-catching colour which is hard to describe - fluorescent tomato, perhaps. Very free-flowering with long-stemmed blooms, and a favourite with those who like to fill vases for the house. Since foliage is rather sparse around the base, it is best with a foreground planting of some kind. It may mildew if it doesn't have good air circulation.

Baronne Edmund de Rothschild (1974)

Large, fragrant, cerise pink blooms, silvery on the underside of the petals, on a vigorous bush. A bold-coloured rose with a good health record, wonderful fragrance and attractive foliage. Needs protection away from the coast.

Chicago Peace (1962)

A "sport" (i.e. a naturally occurring mutation) of the famous rose `Peace', this is usually a better choice than its parent for health and vigour. Golden yellow buds, often with a streak of shocking pink, open into large flowers of more muted sunset colours, each flower of a slightly different hue from the others. As cut flowers, blooms have the same ability to last well, and the same slight fragrance, as the paler `Peace'. In the garden, it makes a rather coarse, angular bush with medium-green, glossy leaves. Both `Chicago Peace' and `Peace' react badly to the usual hard pruning given to Hybrid Teas; once over lightly in spring is the way to go.

Dainty Bess (1925)

One of the oldest Hybrid Teas still in commerce, and one of the more unusual. The silvery lilac-pink flowers consist of five ruffled petals each, surrounding a cluster of marmalade stamens. The short growth makes it a good choice for the front of a bed.

Double Delight (1977)

A compact rose with long-stemmed flowers the colour of vanilla ice-cream dipped in raspberry juice. Grow it in full sun for the most dramatic effect; the contrast is less striking on plants in even a little shade. Really too susceptible to black spot to recommend for the garden - nobody likes the plant, but everyone loves the flower for its striking colour and strong sweet perfume. It often wins prizes at rose shows, both for its blooms and its fragrance, and in 1986 was voted the world's favourite rose for that year.

Electron/Mullard Jubilee (1970)

A vigorous, bushy rose of average height, 'Electron' produces large, hot pink flowers with some fragrance over a long period. Healthy and rain-resistant in the garden, with shapely blooms that hold their colour and last well when cut.The thick, upright stems and large flowers appeal to those who like a tidy plant.

Elina/Peaudouce (1984)

One of the best choices if you want a pastel yellow rose. The bush is larger than average and nicely rounded. The blooms are large and full, and stand up well to rain, which is always a consideration with a pale colour. They begin as primrose-coloured buds and soften as the petals open to a rich ivory, looking beautiful at all stages along the way. A healthy rose, always in bloom.

Folklore (1977)

A strong, healthy rose with rich peach and orange blooms that are excellent for cutting. Produces lots of well-scented flowers which are sometimes reluctant to open in cool weather. This is a tall plant, a good choice to grow beside a warm wall where it can reach up to a window. Otherwise, it needs hard pruning to keep flowers down at eye-level.

Fragrant Cloud (1967)

If you consider fragrance the most important feature in a rose, look no further. 'Fragrant Cloud' more than lives up to its name. So much so, in fact, that it is often banned from fragrance classes at rose shows because it makes short work of the competition. The plant is of medium size with large flowers of a smoky tomato red. Its resistance to disease is unpredictable to say the least - some pronounce it unfailingly healthy while others find it prone to black spot.

Honor (1980)

It's hard to find a good white rose for our conditions among the Hybrid Teas, but the consensus is that this is the best so far. Beautifully shaped, ice-white blooms on long stems make it an

attractive cut flower. The plant is well-clothed with leathery, dark green leaves but is not reliably hardy. Give it a sheltered position and some winter protection.

Ingrid Bergman (1984)

With its velvety texture and fragrant, attractively-shaped blooms on long stems, this has been, since its introduction, one of the most popular dark red roses for cutting. Like many of the roses introduced by the Danish firm of Poulsen, it adapts well to our climate and shows little sign of disease. Several bushes planted together in a formal bed make a grand show which continues well into fall. It can grow to more than 1 m. (3 1/2 ft.) tall.

Liebeszauber (1990)

Fast becoming a favourite among those who like very large, shapely flowers on long stems for exhibition or flower arrangements. The colour is a deep red, and the blooms stand up well to rain. It wants to flower in clusters, more like a Floribunda than a Hybrid Tea, which can make it look ungainly in the garden, but is great for filling a vase. Pinch out the side buds if you prefer a more balanced bush, with flowers one to a stem. On the downside, it has little scent, and the bush is not particularly attractive, with a tendency to send up occasional long canes each year like spider legs. Prune it hard for a more manageable shape.

Lincoln Cathedral (1985)

A tangerine and peach blend which is terrific in a warm, dry location. In rain, the petals dissolve! Included here because it is so very healthy, and at its best gets rave reviews for its colour and growth habit. A thorny bush. Not easy to find, but worth the search.

Loving Memory/ Burgund 81 (1983)

Quite possibly the best all-round red rose that is readily available. A continuing favourite with exhibitors, who like its sultry red, long-stemmed and long-lasting blooms, but also

finding favour in the garden where its bushy growth and healthy dark foliage complement the flowers. Very free-blooming, and quite well-scented, too.

Marijke Koopman (1979)

A shapely rose in two-tone pink, popular with exhibitors. It begins to bloom later than most in this class, but then keeps going strong until October. The tall, upright bush is somewhat prone to mildew, tender in frosty areas and there is little scent, but on the plus side are its generous and continuous production of flowers and the rich colour.

New Zealand/Aoteoroa (1989)

The first rose to challenge 'Fragrant Cloud' for the richness of its perfume, and an easier one to blend with other colours, being of a soft pink. Still too new to North America to judge how it performs over time in the garden, but initial reports are complimentary, with some reservations about its resistance to rain.

Paradise (1978)

Roses in the mauve and purple colour range are inclined to be both well-scented and weak-growing. 'Paradise' fits the mould with its perfume, but is a strong, reasonably healthy plant as well. Its voluptuous Hollywood blend of lavender and ruby red, and a fragrance which harks back to the old tea roses, explain why it is so popular.

Peace (1945)

The world's favourite rose has of late experienced a reduction in its health and vigour, which some experts attribute to its being cloned so many millions of times since its introduction. However, a good plant is still a knockout in the garden, never without some of the large flowers textured like heavy silk and coloured in the pale gold and blush pink of a dawn sky. Stems are long and foliage is glossy green. This is a bush which resents the hard pruning that most Hybrid Teas require; go easy for the best results.

Pristine (1978)

Everyone loves the colour of the blooms on this rose, pearl pink outer petals surrounding an ivory centre. And a classic shape, too. If only individual blooms weren't so fleeting - here today, gone tomorrow. This characteristic plus its coarse stems and huge prickles are drawbacks, but it merits consideration for that dramatic flower, large healthy leaves and its sweet if elusive fragrance.

Rosemary Harkness (1985)

Nominated by the Vancouver Rose Society as its Rose of the Year for 1999, this rose combines vigorous growth with delicate flowers in peach and apricot shades and a rich, fruity perfume. Healthy and prolific, it is often the first rose into bloom as summer approaches. With all these attributes, it is understandably a best seller in West Coast nurseries, and is equally suited to a mixed bed or isolated as a garden feature.

Royal William (1987)

Known in Germany as 'Fragrant Charm', which provides a clue to one of its virtues. Others are the fire-engine red flowers with a velvet sheen, and tough, glossy foliage on a strong, straight plant. On top of all this, it is building a reputation for excellent health. In fact, when you measure it against all the requirements for a good plant, this is a rose that rates a report card of straight As.

Savoy Hotel (1987)

Flawless, porcelain pink flowers on a plant that actually likes our cool summers and responds with lots of bloom. It has no scent to speak of and the flowers refuse to open in prolonged rainy spells, but in every other way it outshines other roses of this colour. Its virtues include a neat habit of growth, dainty foliage, and a constitution unscathed by the chill of winter - much tougher than the delicate flowers would lead you to expect.

Selfridges/Berolina (1984)

Fast developing a reputation as the best yellow Hybrid Tea for our climate, this is a tall-growing plant for the back of the bed with well-shaped blooms on long cutting stems. Introduced by the German firm of Kordes, which is in itself a recommendation for a rose that will likely do well here too. Healthy and hardy, especially for a yellow rose.

The Lady (1985)

The flowers are not particularly large but are well-proportioned on long stems, beautifully shaped, and delicately coloured in a blend of pale honey accented with ice-cream pink. A short-growing plant with healthy, glossy foliage and an abundance of flowers. Needs a sheltered place and/or winter protection, but worth the extra attention.

Warm Wishes/Sunset Celebration (1994)

Almost too new to be considered, as there is no track record to rely on, but it has already received the top award of the American Rose Society, which requires a rose to show outstanding merit in various test gardens across the country for two years. If hardy and healthy here, it will have much in its favour. A glowing combination of peach and coral petals in a classic Hybrid Tea spiral with an appealing, fruity fragrance.

FLORIBUNDAS (Cluster-flowered Roses)

Fast overtaking Hybrid Teas in popularity, at least in their ability to ornament a garden, Floribunda roses make attractive bushes and produce abundant flowers over a long period. Because the flowers bloom in clusters, rather than one to a stem, they are more colourful, if less structural, in the garden, and for cutting they have the advantage that a single stem will often fill a vase. They tend to be more bushy plants than the Hybrid Teas, but need similar attention and protection to endure inland winter conditions.

Anisley Dickson/Dicky (1984)

When a breeder names a rose for his wife, it's a good indication of the high hopes he has for it. This one has certainly fulfilled its promise. The bush is vigorous with huge sprays of flowers in a striking deep salmon, lighter on the undersides. But this rose's outstanding quality is the amount and continuity of its bloom - one of my colleagues counted 120 flowers on a plant in its first year. If it had more fragrance, it would be unbeatable.

City of Leeds (1966)

Here is a rose that has had many admirers over a long period of time. Although considered passé by some, it still has its merits, particularly as a mass planting and as a cut flower. The upright, compact bushes produce a never-ending succession of rich coral pink flowers. The foliage is healthy and glossy green.

City of London (1986)

A tall-growing, almost thornless rose with a powerful fragrance and loosely-petalled flowers in a clear but soft pearl pink. Individual blooms don't last long, especially in rain, but there are always more ready to replace them. Glossy foliage that is generally healthy. Would respond well to being trained as a small climber.

Escapade (1967)

A rose for romantics with spectacular sprays of small flowers, almost single, in lilac pink, brightened by a touch of white at the base of the petals which accents the golden stamens. Sweet fragrance. This is a healthy, easy to grow plant that will flower all season long and responds well to hard pruning.

Eyepaint (1975)

An exceptional sight in full bloom when clusters of single, bright scarlet flowers, each with a white "eye", envelop the bush. It has a vigorous flowing habit of growth and the flowers continue unabated for a long time. No scent and it does need dead-heading to keep it looking its best, but is hard to beat for garden display. A good choice for a feature plant, or at the back of a mixed planting.

Fellowship/Livin' Easy (1992)

A rose that generates a lot of enthusiasm wherever it is grown. "On fire" best describes a bush in full bloom. Attractive, long-lasting flowers in glowing orange just keep coming non-stop on a medium-sized bush with dark, glossy foliage. It does have a tendency to black spot , but there is no doubt that it is a winner in its colour class.

Friesia/Sunsprite/Korresia (1977)

Here's a rose that has become a classic world-wide, no matter which of its names it appears under. The canary-yellow clusters of bloom hold their colour well and have a heavenly scent. Flowers don't last long but the spent petals drop cleanly, and more are always opening on this neat, glossy-leaved bush. Take advantage of its compact growth to plant it in a group of three for a great effect, or use it as a low hedge.

Glad Tidings (1988)

Frequently rated as the best red Floribunda for its excellent health and the huge trusses of shapely, scarlet flowers that are

impervious to the weather and last forever. Popular with exhibitors and garden lovers alike, its only drawback is a lack of discernible fragrance.

Iceberg (1958)

Undoubtedly the world's favourite white rose and deservedly so, unrivalled after forty years. Pure white flowers like camellias cluster densely against a background of clear green stems and leaves. Even though it is only lightly scented and black spot can be a problem, no-one has a bad word to say about this rose. Choose the climbing form if possible for its better health and tremendous show of bloom.

Lavaglow/Lavaglut (1978)

The sultry, deep red - almost black - velvet blooms on this compact little rose are utterly weatherproof, not spotting in rain, not fading in sun, and lasting for a long time. Individual flowers are small, but since they bloom in large, flat-topped clusters they have a way of attracting attention more effectively than most flowers in the garden. Dark green leaves with a hint of bronze add to the thundercloud effect. Unfortunately, there is little scent.

Liverpool Echo (1971)

Clusters of fragrant salmon to pink flowers on a tall bush, too lanky for some tastes, but useful if you need a rose under the kitchen window to view from inside the house and waft its scent across the sill. The shapely flowers look as though they were designed to grace a florist's corsage.

Margaret Merril (1977)

A rose that finds favour with everyone primarily for its delicious fragrance but also for the charm of its flower. The pearly white, high-centred flowers are beautiful both in bud and fully open. The bush is upright with shiny foliage. The flowers don't like rain and the plant needs winter protection, but three international gold medals for overall appearance and four more for fragrance are not to be taken lightly. When Peter Harkness,

head of the company that introduced this rose, was visiting Vancouver, he told an intriguing story about the name of this rose. All roses named for people must have the consent of the person whose name is being used. 'Margaret Merril' was named for a columnist in an English newspaper who, as it turned out did not exist - the name was a made-up one for the column. Accordingly Harkness Roses placed an advertisement looking for a real Margaret Merril and three women responded. One of them willingly signed the release for the company to use her name.

Mountbatten (1982)

Primrose yellow, double blooms on a tall, wide, bushy plant, excellent for the mixed garden. Healthy and free-flowering, with a pleasing, though not strong, fragrance, shapely flowers that hold their colour well, and crisp, shiny leaves. A good choice for poorer soils.

Pensioner's Voice (1989)

Long-stemmed, soft apricot flowers with the form and substance of a Hybrid Tea make this a popular rose with exhibitors and garden growers alike. A free-flowering, hardy plant. Highly recommended.

Playboy (1976)

Exquisite, five-petalled, frilly flowers in brilliant shades of yellow and orange - so cheerful it almost laughs at you across the garden. A clever combination of simple shape and vibrant colour that successfully walks the line between understatement and excess. The bush is strong and healthy with glossy, dark green leaves, but could use some extra protection in winter.

Queen Elizabeth (1954)

Probably the most widely grown pink rose in the world, and justifiably, for there is no rose more reliable, hardy and easy to grow. Classed as a Grandiflora in the United States, it combines the flower form of a Hybrid Tea with the free-flowering habit and greater hardiness of a Floribunda. This is a plant that can grow

to a strong free-standing shrub of as much as 3 m. (10 ft.) without pausing for breath, and even in the worst conditions will put on a brave display. With excellent disease resistance, and constantly in bloom with masses of china pink, elegant flowers on long stems, it disappoints only in its lack of perfume. Dark, leathery foliage is somewhat sparse on the sturdy canes; prune it hard if you want a more compact, leafier bush with flowers at eye-level.

Radox Bouquet (1981)

Those whose ideal rose is pink and richly scented should consider this healthy, vigorous plant which has received surprisingly little attention in this part of the world. Lots of fat buds open into, lush, full-petalled blooms with something of an old-fashioned look on a tall bush. It would be an asset to a mixed border in any garden – an attractive flower, constantly in bloom, and made extra-special by the powerful fragrance.

Sexy Rexy (1984)

If shape is everything and scent doesn't matter much, this has to be first choice as the most beautiful rose in this class. Dense sprays of waxy, shell pink flowers are almost too perfect to be real, the petals layered one upon the other like the petals of a camellia. Blooms in distinct flushes throughout the season, but so generously that you may have to stake it to support the weight of the flowers - a single cut will fill a vase!

Sheila's Perfume (1985)

A dazzling rose for the senses -sunshine yellow flowers with an edge of hot strawberry and, as you would expect from the name, a strong, fruity fragrance. The flowers are elegant, too, with the classic shape of a Hybrid Tea and grow one to a stem or in small clusters. Bushes are healthy and well-endowed with leathery, green foliage. This is one of very few roses raised by an amateur hybridizer that has achieved international popularity.

Tabris/Raspberry Ice (1986)

A rose that always attracts attention, both in the garden and on the show table. Elegant soft cream flowers, tipped with bright carmine at the edges decorate the strong, upright bush. Indistinguishable from both 'Nicole' and 'Hannah Gordon' (or the same - opinions vary!)

Trumpeter (1977)

A compact, healthy bush which decks itself from top to bottom in flowers of fluorescent vermilion. Blooms so heavily that it has to take a breather between bursts of bloom. When it is in flower it may need some support to hold up the heavy trusses. Not much scent - fragrance seems rare with this colour - but it's the way this rose glows in the garden that will draw you to it. The short growth makes it suitable for small gardens or the front of large beds.

SHRUB ROSES

This is a catch-all term for a wide-ranging group of roses that don't fit the specifications for Hybrid Teas or Floribundas. It usually includes the Old Garden Roses and the David Austin English roses, but I have given both these their own headings because they are such important sub-groups with shared characteristics that set them apart from the rest of the pack.

The remaining roses share only the distinction of flowering either continuously or at least twice during a season. They range from huge bushes to small, neat plants to wide-spreading ground-huggers. Their flowers may be huge or tiny; they may have many petals, a dozen loose and frilly ones, or as few as five petals each. Leaves may be green, grey or copper-coloured, small and fern-like, or large and rough-textured; many have good autumn colour. Most of this group are fragrant. Some are a little on the tender side except in coastal areas; others, like the Rugosas, are not only impervious to disease but tough as old boots.

Alba Meidiland (1987)

One of a series of roses bred in France for planting as groundcover alongside highways, this little rose flowers incredibly heavily from June until frost with clusters of small white rosettes that develop a tinge of pink as they age. It is a low-growing, hardy rose, tolerant of poor soil and neglect, as you would expect. Sometimes gets a little diseased by late summer, but is able to shrug it off without any effect on vigour. No scent to speak of. There are other colours, including 'Pink Meidiland', 'Red Meidiland' and 'Pearl Meidiland', and another white, 'White Meidiland' with fewer but larger flowers in each cluster, but ' Alba M.' is the stand-out in my opinion.

Ballerina (1937)

Long a great favourite in a perennial border or as a low hedge, 'Ballerina' also looks attractive in a large planter. It flowers in dense clusters of single pink and white blooms reminiscent of apple blossom, which continue over a long

season. The generous amount of flower, capable of hiding the foliage almost completely, makes up for its lack of fragrance and a tendency to speckle as it ages. Without conscientious deadheading it can quickly become ugly. Although it is normally a small plant, growing to around 75 cm. (21/2 ft.) ,an occasional specimen has been known to send up long shoots like a climber. For those who prefer a stronger colour, there is 'Marjorie Fair' (1977), the same rose in red and white. If you can find it, 'Fleurette' (also 1977) is similar to 'Ballerina' but with better colouring and more continuous bloom; it ages more gracefully and has lovely bronze foliage as well.

Blanc Double de Coubert (1892)

One of the oldest and best Rugosa roses for a number of reasons. The fragrant flowers, like paper roses made from two rows of pure white petals, begin early, often before the end of May, and end late in fall. The foliage, impervious to disease, turns bright gold in fall before dropping. Although it does not make many hips, those that do appear are large and bright red, contrasting well with the turning leaves. This is a big plant, anywhere from 1.5 to 2.5 m. (5 to 8 ft.) high and wide, and makes a good, prickly barrier as a hedge, or can stand alone as a focal point in a garden. Its only disadvantage: the petals do not drop cleanly as they begin to turn brown. Rosa rugosa alba has much the same characteristics but its single flowers shed their petals when spent.

Bonica (1985)

Highly recommended as an undemanding shrub for all types of situations, this is a healthy, hardy rose that will tolerate some shade. The pretty, pink, loose-petalled flowers bloom profusely over a long period and are followed by colourful orange hips that last through the winter.

Buff Beauty (1939)

A forerunner of the Austin shrub roses and, in my opinion, superior to them in a number of ways. The growth habit is strong and self-supporting, developing into a rounded bush of

roughly 150 cm (5 ft.); the young stems and foliage are an attractive shade of plum purple, maturing to deep green with bronze overtones; the fragrance is sweet and fresh, and the plant is healthy. As for the flower, it is an old-fashioned rosette of many short petals in shades of softest chamois. A true classic, blooming in June and again, even more heavily, in September with an occasional flower or two in between. 'Cornelia' (1925) is similar but with smaller flowers in an unusual shade of pale strawberry.

Chinatown (1963)

Sometimes classed with the Floribundas, this is a vigorous, leathery shrub whose large, pale gold flowers are lightly brushed with pink. A combination of rich perfume and long-flowering habit have helped to keep this older variety among the most popular yellow roses.

Darlow's Enigma (undated)

As the name reveals, this is a mystery rose, discovered in a Seattle garden. It looks in every way like a species rambler with fragrant, open sprays of small, single white flowers, yielding in fall to hips like shiny little orange beads. The difference is that this rose is never out of bloom all season long. Lacy, light green foliage is impervious to disease. In all ways a remarkable plant, which can be grown as a climber or pruned to a large free-standing bush. Although it is not readily available, it is can be found through some of the companies listed in the section on Sources.

Flower Carpet (1989)

Included because of its reputation as a disease-free, ever-blooming rose, and it is indeed very easy to grow, making a spreading low mound of bright green foliage studded with small, bright pink flowers. Impervious to powdery mildew and black spot, this is a good rose for the beginner, or for anywhere a minimum of maintenance is all it can expect. Flowers emerge later than most roses, but once under way there are always some on the plant. On the downside, there is no scent, and downy mildew can be a problem.

Felicia (1928)

Along with 'Buff Beauty' and 'Penelope', one of the small group of Pemberton musk roses that have been loved by gardeners since their introduction early in the century. Sprays of soft pink, sweet-scented flowers cover the vigorous but graceful shrub in June, and continue sporadically until autumn when an even more impressive repeat performance takes place, the last flowers opening even as the first frosts begin.

Fred Loads (1968)

You'll either love or hate this rose, depending on how you respond to neon flame-red as a colour. Each flower is only five large petals, but they bloom in huge eye-catching trusses on a tall plant. One of my friends has combined it with a weeping blue spruce to great effect. Minimal disease, long flowering season and even some fragrance make it a winner if you want to stop visitors in their tracks.

Fru Dagmar Hastrup (Hartopp) (1914)

Bred in Denmark, this hardy Rugosa rose is one of the most compact of its family, suitable for the smaller garden. Its large, single flowers of glistening silvery pink with a heart of golden stamens continue to bloom over a long period and the foliage turns russet and old gold in fall. As if this weren't enough, it is famous for the immense size of the hips that end its blooming season, hanging from the prickly, grey stems like clusters of cherry tomatoes.

Golden Wings (1956)

A truly elegant rose with many admirers. Blooming in loose clusters, each large flower consists of five pale yellow petals surrounding a corona of amber stamens. Clear green leaves clothe the strong stems. It has a mild, orange-blossom fragrance. This is a large shrub which can provide structure to wide border or stand alone as a garden feature. With regular deadheading, flowers continue well into autumn when they can be left to produce flask-shaped grass-green hips. Prune fairly hard to avoid spindly growth.

Hansa (1905)

A versatile old member of the Rugosa family, making an excellent hedge, standing alone as a specimen plant, or backing other plants in a perennial border. Double, cerise-violet flowers with a spicy fragrance begin in June and continue until late in the year, when some will produce spectacular crab-apple-sized hips. The characteristic coarse, wrinkled foliage never succumbs to disease. Tolerant of freezing weather, poor soil, salt air and wind, this is the rose to convert those who believe they can't grow roses. If you can't find 'Hansa', 'Roseraie de l'Hay' is a similar rose and 'Dart's Dash' is a good alternative for a smaller space.

Henry Hudson (1976)

Another member of the Rugosa group, this is one of nicest in the "Canadian Explorer" series, part of a rose breeding program conducted at Agriculture Canada's Ottawa research station to produce roses hardy enough to withstand the fiercest Canadian winters. A rounded shrub of moderate height, it produces a generous display of large, open flowers of creamy white, tinged with pale pink; from their delicacy you'd never guess how tough this rose really is. It has the drawback of not dropping its spent petals which has earned it the nickname "Dirty Henry" in some quarters, but deadheading encourages another flush of bloom so is worth doing anyway. Thorny, impenetrable growth makes it excellent for a low hedge. Others in the Explorer series include `William Baffin' (1983), vigorous enough to grow as a climber, with loose, strawberry-pink flowers in great quantity; `Martin Frobisher' (1968), which has small, powder-pink flowers and delicate foliage on an upright plant with wine-coloured stems; and `Charles Albanel' (1982), a low, spreading shrub with bright cerise-pink flowers and attractive hips.

Lavender Lassie (1960)

One of very few Hybrid Musk roses from the latter half of the century, this is a rose with eye-catching clusters of ruffled flowers in a colour more pink than lavender, and a fragrance reminiscent of lilacs. A strong-growing, healthy plant, tolerant of most conditions, with a succession of blooms from summer to late fall.

Penelope (1924)

A star among stars, this is the most admired of all the hybrid musks bred by the Rev. Joseph Pemberton, an English village vicar and rose hybridizer. Clusters of delicate semi-double flowers open from honey-pink buds into milky white flowers with pale gold stamens. Plum-coloured stems and bronze leaves edged in burgundy enhance the effect. The fragrance is reminiscent of the paperwhite narcissus that blooms indoors in winter. There are two distinct flushes of bloom, one in June and an even better display, with richer colour in the petals, in early fall, with sporadic flowers in between. Grow it as a large shrub to 150 cm. (5 ft.) or prune hard to keep it low and compact.

Sally Holmes (1976)

A giant of a plant, often listed as a climber in more temperate zones, which can be mistaken at a distance for a summer-flowering rhododendron. The flowers, of course, are quite different and much more beautiful; single and ivory-white, they bloom in enormous clusters of up to fifty on one stem, opening in swift succession from fascinating pointed buds the colour of pale smoked salmon. Waves of bloom continue from summer to fall, encouraged by the deadheading of the spent trusses. Excellent health provided it is kept well-fertilized to support the immense quantity of flowers. If only it had fragrance!

Sir Thomas Lipton (1900)

Several Rugosa roses have appeared already in this section, and indeed there is no group of roses more hardy and disease-free. This one makes a tall, thorny bush with ice-white flowers whose green-tinged outer petals seem to reflect the crisp colour of the foliage. They have a more sculptured look than most rugosa blooms, curving like the wide bowls of champagne glasses, and flower in fragrant clusters throughout the season. Prune quite hard to keep the blooms down where you can see them, or plant where you can look out over them from a raised deck. This is one Rugosa that does better in the cooler coastal summer than it does in the more extreme climate of the Interior.

Snow Pavement (1989)

One of a fairly new series of Rugosa hybrids, suitable for the smaller garden. The exceptionally fragrant white blooms open from lavender buds, and the plant has all the Rugosa virtues of health and hardiness. Grows thickly to about 1 m. (3 ft.) high and more than that wide, which makes it suitable for use as a low hedge or a groundcover. There seems to be some confusion among garden centres between this rose and a similar 1984 introduction called 'Snow Owl'.

The Fairy (1932)

Sprays of miniature, shell pink blooms like little pompoms on a compact, leafy bush do not open until July but then continue in generous profusion until November frosts shut them down. This constant bloom and its unparalleled adaptability have kept 'The Fairy' high in popularity since its long-ago introduction. It doesn't just tolerate neglect, it blatantly defies it, and will willingly grow and flower in much more shade than most roses endure, although the flowers will be paler. Dainty grass-green foliage of immaculate health. Alas, no scent.

Thérèse Bugnet (1950)

A Rugosa hybrid bred in Alberta and remarkable for its attraction in all seasons. Although there is never a great profusion of bloom, the clear pink, scented flowers dot the narrow, vase-shaped bushes over the summer months. In autumn the foliage, smoother and more delicate than a typical Rugosa, turns from smoky blue-green to a sultry blend of russet and purple. In winter the naked, almost thornless canes gleam in muted cherry red, particularly nice against a snowy landscape. Very healthy and positively hates to be sprayed. Sometimes reluctant to flower when young and subject to occasional blind shoots but included here for its year-round virtues.

David Austin's English Roses

A relatively recent sensation in the rose-growing world, the roses bred by David Austin, an English hybridizer and nurseryman, combine a flower similar to the rosette of many short petals which characterises the Old Garden Roses with the much longer blooming season, and in some cases more vibrant colour, of modern hybrids. The foliage is decidedly modern-looking, and the flowers are in most cases larger than old roses. This latter trait has its disadvantages as the stems are not always strong enough to hold the weight of the blooms; they are best planted behind shorter, sturdier plants, which may or may not be other roses, so that the flowers have a support to lean on. Otherwise, be prepared for drooping blooms. Many of these roses are also distinguished by a strong fragrance which people either love or hate, so that it has been variously described as smelling like myrrh or medicine.

There are both compact and tall varieties available, although Austin's own estimates of mature height are proving to be on the low side for our conditions. In fact, some that he describes as tall bushes grow more like climbers here. Suffice it to say that the height of these plants is given with a word of caution, as they vary considerably in different gardens. So many Austin roses are new to North America, with more varieties introduced each year, that they haven't yet established a reliable track record. Those recommended below may not be the newest, but they have been around long enough to win local approval.

Abraham Darby (1985)

Immense apricot flowers, which look spectacular in good weather but collapse under their own weight in rain. Giving this plant some sturdy support will help. A much more fruity fragrance than most of the Austins and glossy, healthy foliage contribute to its value. Makes a large, arching shrub, easily 150 cm. (5 ft.) wide and tall, so allow it plenty of space.

Belle Story (1984)

A double row of shapely, powder-pink petals surrounds a cluster of golden stamens, giving each flower the look of a delicate camellia. Strong growth to 150 cm. (5 ft.) but surprisingly little fragrance for this group.

Fair Bianca (1982)

A good choice for the smaller garden, 'Fair Bianca' has parchment white, cupped blooms opening into flat rosettes. The myrrh fragrance is particularly strong in this rose. Height about 75 cm. (30 in.). Just a little on the tender side and should receive some light protection in winter.

This is one of a series of roses that David Austin named after characters in Shakespeare's plays. (Bianca appears in The Taming of the Shrew).

Gertrude Jekyll (1986)

A rose which has inherited the superlative old-world fragrance and some of the beauty of one of its parents, 'Comte de Chambord' (q.v.). The flowers are a rich pink, quite modern-looking in the bud, but opening into large, quartered rosettes. Growth is tall and stiff, not very graceful but dense with foliage and flowers.

Graham Thomas (1983)

Perhaps the most popular Austin rose, introducing a depth of colour unequalled among yellow roses. It is a tall, upright bush, capable of reaching 2 m. (7 ft.), or in ideal conditions considerably more. The globular flowers open into cupped chalices and are an intense topaz gold. The fragrance is reminiscent of old-fashioned tea roses. Medium-green foliage which has a slight tendency to mildew on the coast. This rose is named for Graham Stuart Thomas, England's leading authority on roses, especially Old Garden Roses. His books on roses, as well as on other plants, have a world-wide reputation, and the rose garden he established at Mottisfont Abbey, near Winchester, is worth a pilgrimage.

Heritage (1984)

The softly cupped, blush-pink flowers of this rose are among the most attractive of its group, and the plant is a strong and vigorous grower. The blooms are well-scented with a citrus tang. This rose is a good choice for the back of a mixed border, or for growing over a gate or trellis where its canes can arch naturally, encouraging additional clusters of flowers along their length. Height to 150 cm. (5 ft.) or more.

L. D. Braithwaite (1988)

Austin's best red rose to date with lots of blooms on sturdy stems. Dark green, leathery foliage complements the glowing flowers. Always in bloom, with a spreading habit and very healthy. The fragrance, however, is slight compared with others in this group.

Leander (1982)

Not an easy colour to categorize, being one of those pale melon shades that hovers between pink and apricot, but an outstanding plant, growing so tall in our area that it is best treated as a climber. Although listed as once-blooming in summer, it will produce some later flowers when it is well-established. The flowers are elegant, flat rosettes with an attractive apple scent.

Mary Rose (1983)

A strong, healthy rose with large, fragrant, candy-pink flowers and arching growth on thin stems to about 150 cm. (5 ft.) or more. It was the Vancouver Rose Society's selection for its Rose of the Year in 1998, and is reputed to be one of the hardiest of the Austins. For those who don't like pink, there is a white form called 'Winchester Cathedral', as well as a softer pink, 'Redouté'.

Pat Austin (1997)

The unusual copper and amber colour of 'Pat Austin' is likely to appeal to many gardeners. Although too new to judge yet, it

has been launched to great acclaim in England, and the fact that Austin has named it for his wife is an indication of how highly he regards it.

St. Swithun (1993)

Large, soft pink flowers like frilly rosettes with the characteristic myrrh scent very much in evidence. The bush is vigorous, upright and hardy.

CLIMBERS

Climbing roses don't really climb in the way that vines do. Their sturdy canes have to be secured to a support, preferably a fence or trellis that allows good air circulation & so discourages disease. Most climbers are repeat-blooming, and some have such thick, inflexible stems that they require very little in the way of an anchor to keep them in position. If you want to clothe an arch on both sides, plant two climbers, one on each side. Be sure to read up on the pruning recommendations for this type of rose (Chapter 6) as the wrong technique will result in very few, if any, flowers.

Altissimo (1966)

Blood-red single flowers of great beauty with a coronet of golden stamens at their heart make this a spectacular sight in bloom, which it always is from summer to fall. Even people who don't like single flowers love this one despite its lack of fragrance. The growth is rather stiff and angular, so it is best fanned against a high fence. Dark, healthy foliage, and a mature height of about 3.5 m. (12 ft.)

City of York (1945)

Although there is only one heavy cascade of bloom in summer, the creamy white clusters of double flowers with lemon centres make a grand display during that time and are followed by sizeable hips that give the plant some later value in the garden. An exceptionally healthy climber with a scent like oranges. Height about 4.5 m. (15 ft.)

Compassion (1973)

Rated Great Britain's most popular climbing rose, this versatile plant can be trained against a fence, around a pillar, over an arch, or even pruned as a free-standing shrub. The large Hybrid Tea-shaped flowers are tinted in warm shades of salmon pink and apricot, and are strongly perfumed. Blooms come alone as well as in small clusters on strong canes. On the tender

side in our climate, and subject to mildew where air circulation is poor. It can reach a height of 3.5 m. (12 ft.)

Constance Spry (1961)

This is the rose that began the dynasty of David Austin's English roses. Although it blooms only once, and then for a month at most, the warm satin-pink, globular flowers are so fragrant and make such a spectacular display that it merits a place in any garden. The attractive grey-green leaves make a satisfying backdrop for later blooming plants when its own flowers are done. Often pictured in English gardening books blossoming romantically behind an elegant white bench. You can forget to water, deadhead or fertilize this rose and it will thrive in spite of you. Good health and arching growth to 2.5 m. (8 ft.) high and wide. It can also be grown as a large shrub, but be sure to prune it like a climber as it flowers on the second-year growth.

Dortmund (1955)

Bright red, single flowers with a circle of white around the golden stamens create a vivid curtain of colour to brighten a gloomy corner, particularly as the plant adapts well to dappled shade and is capable of competing with trees for nutrients and moisture. Although individual flowers are small, they bloom in large trusses, and should be deadheaded if you want to encourage continued bloom. Height & width: 2.5 m. (8 ft.)

Dublin Bay (1974)

Simply the best red climbing rose for the west coast, visually that is. Rather stiff canes make it a candidate for fanning against a supporting structure such as a low fence or a fan trellis. The flowers are fire-engine scarlet against brilliant green leaves, a combination that draws the eye from a considerable distance. The season of bloom is continuous and long, but leaves little energy for scent as well. Average height 3 m. (10 ft.)

Etoile de Hollande (Climbing) (1931)

Not the healthiest of climbers but it is included here because it possesses one of the most scented flowers in this category. This is a strong rose with thick canes, rather sparsely covered in emerald-green foliage. The flowers are a deep, glowing red, beautifully shaped, with a fragrance that all roses should have, the kind that perfume companies are always trying to reproduce. Height to 3.5 m. (12 ft.)

Handel (1965)

This rose, with its shapely scrolled buds opening into Hybrid Tea-style blooms of ivory edged in deep pink, created something of a sensation when it was introduced. Masses of bloom in spring and late summer with lesser flushes in between. It has drawbacks: stiff, inflexible stems, little scent and a inclination towards black spot, but if you don't mind maintaining a regular spray program, it will certainly provide you with a visual treat. Grows to about 3.5 m. (12 ft.)

Iceberg, Climbing (1968)

Better than its parent, as many climbing forms are with their extra vigour. For a description, see under Floribundas.

Jeanne Lajoie (1975)

Among the first of the climbing miniatures with little candy-pink pompoms of flowers, blooming in great waves from summer to fall. Although it has a tendency towards black spot, it recovers well. No scent, but still a good option for a smaller space, or for growing in a large container. Will grow to 2 m. (6 ft.) or more.

Lichtkonigen Lucia (1985)

Although it's often listed as a shrub, this rose is much more likely to respond like a short climber in our conditions and, as such, it outperforms even the much-admired 'Golden Showers', which has long been the standard for a yellow climber. It blooms in clusters of clear sunshine-yellow flowers which do not

fade and have a sweet fragrance. The foliage is dark and disease-free. A versatile, almost thornless grower which will clothe an arch, wrap a post or drape the side of the house. Height depends on the way it is trained - up to maybe 3 m. (10 ft.)

Madame Alfred Carrière (1879)

Most of the Noisette family of roses are too tender to do well this far north, but 'Madame' is an exception. Luckily for us, because this is to my mind a rose without peer. The exquisitely-scented white blooms open from pink pearl buds, singly or in softly drooping small clusters, filling the evening air with their fragrance. A mass of bloom in summer and then never without flowers until frost, with a second generous display in fall. Long, flexible canes make it ideal for training over a trellis or up into the open branches of a tree where the flowers can cascade from above. Some feel the limp leaves give it a tired look and mildew can be a problem in late summer but the rose is strong enough to shake it off without any apparent loss of vigour. At maturity, it tends to be bare around the base, so is better surrounded by tall bulbs or well-mannered perennials. Growth to 4.5 m. (15 ft.)

Madame Grégoire Staechelin/Spanish Beauty (1927)

A climbing Hybrid Tea rose with huge, ruffled flowers in two tones of pink - the pale and darker petals layered like the skirts of a Spanish dancer. Everything about this rose is larger than lifesize. It blooms once, early in summer with masses of sweet-pea scented flowers on robust canes, and produces clusters of bright green hips like small pears, which slowly ripen to a pale pumpkin hue and last into late winter. Tends to bear its flowers high, and is best grown over a pergola where they can hang down from above. Bare canes lower down benefit from screening with other shrubs or perennials. Large leaves are resistant to everything except rust -don't grow it if this is a problem in your garden. To 4.5 m. (15 ft.) or more.

New Dawn (1930)

Strictly speaking, this rose should be listed as 'The New Dawn', its registered name, but it is more often found under the two-word title in catalogues and books. This is the rose that has it all: beautiful flowers of pale shell-pink, excellent repeat bloom, distinct fragrance, vigour, and good health, except for a tendency towards mildew on the tips of the canes late in the season. Its flexible canes will wrap an arch or cover a spread of fence as effectively as any rose, and they are well clothed in glossy green foliage which highlights the shapely flowers. Blooming continues well into fall. Trivia buffs may be interested to know that it was the first rose ever to be granted a patent. Growth to as much as 4.5 m (15 ft.)

Royal Sunset (1960)

A strong-growing plant with shapely, large, Hybrid Tea-style blooms in rich apricot. Copper highlights in the dark foliage enhance the impact of the flowers. Well-scented. Strong, stiff growth means that it is best against a wall or solid fence where it can be fanned out over a large area. Blooms heavily in early summer and is never without flowers thereafter. Around 3 m. (10 ft.)

Sombreuil (1850)

The oldest rose in this category, and the only old Climbing Tea rose both hardy and healthy enough to recommend for our climate. Sweetly scented, creamy-white flowers with that ruffled old rose look spangle the lush green foliage in early summer, and continue sporadically into fall. The perfume is more intense in this later blooming. A rose of classic beauty, which benefits from a warm location; in colder sites, it can be grown as a shrub, but loses some of its structural elegance. To 3 m. (10 ft.)

Sparrieshoop (1953)

Large clusters of pointed buds open into rich pink, single flowers with crimped edges and a froth of golden stamens at the centre. The petals are often faintly veined in darker pink and touched with ivory at the base. Very free-flowering and may be

grown as a shrub, but its lankiness makes it a better choice for a short climber. It needs an airy location to circumvent a tendency towards powdery mildew. To 2.5 m. (8 ft.)

Warm Welcome (1991)

An absolute standout in several ways, this miniature climber will reach 2.5 m. (8 ft.) and clothe itself from top to bottom with masses of shapely little tangerine blooms. Contrasting foliage that is purple when young, bronze-tinted later, sets this rose apart and endears it even to those who normally shy away from orange tones. Leaving spent blooms on at the end of the season allows the attractive hips to form. Healthier than most miniatures with stiff upright growth that suits growing on a pillar. Not as colourful but with a more pronounced scent is the yellow miniature climber 'Laura Ford' (a.k.a 'King Tut'), which will also set hips if not deadheaded.

Westerland (1969)

Dazzling golden and apricot, wavy blooms on sturdy canes appear in distinct flushes from late spring into fall against a backdrop of exceptionally healthy, large, dark leaves. The scent is strong and fruity. Listed as a shrub, but our conditions often persuade it to as high as 2.5 m. (8 ft.) , which makes it suitable for arbors and fences. Cut out old canes every few years to encourage new growth and more flowers.

White Cockade (1969)

A flower that has the same shapely form as its parent 'New Dawn', but lacks its quality of perfume. Pure white flowers amid dark green, glossy leaves give it the elegance of a gardenia. The stiff canes respond best to being fanned against a fence or wall. A thrifty plant that metes out its flowers evenly across the summer and fall - no big show, but a steady output of bloom. Good health and reasonably tolerant of dappled shade which intensifies the contrast of flower and leaf. Short for a climber, to 2.5 m. (8 ft.)

RAMBLERS

The characteristics that distinguish ramblers from climbers often overlap, and so some roses may find their way into either category. Those listed below have wiry, flexible stems that allow them to be wound through open fences, around pillars or through the branches of trees. With some encouragement in the first few years, they can also be trained up the sides and over the roofs of ugly buildings to turn them into swans for at least part of the year. Most ramblers have one glorious burst of bloom in July, followed by a display of hips in fall and winter. A few give some late flowers here and there, and a very occasional one will give a second satisfying flush of flowers in autumn. Almost all are well-scented, and the best can envelop a garden in perfume. Although 4.5 m. to 6 m. (15 to 20 ft.) is the average mature height, some varieties are capable of more; if so, this is mentioned in the description. As the dates of introduction show, this is a class of roses that has had few new entries in the last century, a pity since their adaptability, healthiness and stunning display of bloom is not equalled by any other class of rose.

Albertine (1921)

One of the famed French hybridizer Barbier's introductions and possibly the best known. In full bloom it is covered with large, coppery-pink, dishevelled flowers opening from reddish buds. The perfume is rich and seductive. Strong plum-coloured canes are well armed with vicious thorns. Once-blooming but with a few later flowers in fall when established. 4.5 m. (15 ft.)

Adelaide d'Orléans (1826)

Cascades of softest pink to white, semi-double flowers with golden stamens make this rose a breathtaking sight in bloom. Neat green foliage with a purple tinge survives a mild winter, and leafs out quickly after a more severe one. The fragrance is strong and sweet, reminiscent of primroses. This is an excellent rose for twining through an open fence or a trellis, and is high on my desert-island list of the roses I couldn't live without. 4.5 m. (15 ft.)

Albéric Barbier (1900)

Almost a century old, another of the excellent ramblers raised by the French grower Barbier, this one has clusters of butter-yellow buds which open into creamy-white rosettes, sharply framed by the glossy, dark green foliage. A fruity fragrance and the ability to produce a few more flowers in early fall contribute to its appeal. Wide-spreading and very vigorous to 4.5 m. (15 ft.)

American Pillar (1902)

If you want a show-stopping display for little or no effort, look no further. Here's a rose that just smothers itself in bright pink flowers with a touch of white at the centre. Once established, it can be utterly neglected, being both vigorous and hardy. Its only failing - no scent to speak of. Best on an open structure like a wire fence or a lattice, as it does have a tendency to mildew where air circulation is poor. 4.5 m. (15 ft.

Bobbie James (1961)

Named for the Englishman on whose property it was discovered (see 'St. Nicholas'), this is a giant of a plant, quite capable of enveloping a three-car garage, or scaling the tallest tree. More reliable in our climate than the better-known 'Kiftsgate', it has similar huge trusses of simple, white flowers with a pervasive fragrance, and is sprinkled with small red hips in fall. 6 m. (20 ft.)

Chevy Chase (1939)

It is surprisingly difficult to find good red ramblers, and perhaps that is why this old American favourite is undergoing a new surge of popularity. Each large cluster contains many fully-double blooms of brilliant crimson which are pleasantly scented. Grass-green leaves contribute to the dazzling effect.

Félicité Perpétue (1828)

This thorny rose and its sister, 'Adelaide d'Orléans', are among the small group of sempervirens ramblers still available

today. Both live up to their "evergreen" description in a mild winter, and are among the first to leaf out again if they do lose their leaves. This one begins its flowering season with clusters of lipstick-pink buds, opening into tiny rosettes of purest white. The effect of a half-in-bud, half-fully-open specimen is a beautiful sight, and flowering continues over four to five weeks. Very healthy - hates to be sprayed, in fact - but not as fragrant as its sister. 4.5 m. (15 ft.)

Francois Juranville (1906)

A very vigorous grower whose frothy, salmon-pink, quilled flowers have a fruity fragrance. Dark bronze-tinted foliage contrasts well with the blooms. This is an excellent choice for a pergola or to cover a stretch of fence, and in a good year will produce a few extra flowers as the season progresses. 5 m. (17 ft.)

Ghislaine de Féligonde (1916)

One of the few really reliable repeat-blooming roses in this category, and better than any for its excellent health. The colour is unusual in this category, too, being an attractive apricot and pale honey blend, darker in the bud and paling to cream when fully open. Individual flowers are small, but well-shaped and come in neat, rather elongated clusters. The canes are almost thornless, which makes it useful for doorways or arches, and the foliage is fern-like and a glossy grass green. Although not tops for fragrance, it has enough to satisfy the nose. It can also be grown as a large shrub if pruned appropriately. 2.5 m. (8 ft.)

Lykkefund (1930)

A rose from Denmark whose name translates into English as 'Lucky Find'. Lucky it may be, but not easy to find in North America. However, it is available through specialty nurseries, and rates a mention for several reasons. First, its fine, narrow leaves are exceptionally healthy; second, it has outstanding fragrance; and third, it is virtually thornless,which makes it a great choice for planting where people might brush against it as they walk by. Best of all, it offers a mass of butter-yellow buds

opening to semi-double cream flowers overlaid with a wash of peach, each petal with a central vein of yellow. Add sprays of vermilion hips in the fall and you have a rose for all seasons. Adaptable too - can be left to ramble or pruned to make a large specimen shrub. 4.5 m. (15 ft.)

Phyllis Bide (1923)

A free-flowering rambler which always manages to have some blooms on it, from the first generous flowering onwards. Delicate, cupped buds open into clusters of pastel flowers variously shaded in peach, buff and pale yellow with lots of dainty green foliage to act as backdrop. In our unpredictable weather, the flowers are inclined to become somewhat mottled as they age, but this is a minor fault among so many good points. There is some fragrance but it is not strong. 3m. (10 ft)

Rosa mulliganii (1917)

Here is another of the giants, a common sight in the famous gardens of England but not so well-known here. My two plants effortlessly cover about 12 m. (40 ft.) of fence-line each. When they bloom, their scent fills the garden. The foliage, small and glossy green, is almost obscured by the huge, loose sprays of small, single flowers in July and ages to old gold and a dusky red in fall. Vivid little red hips sparkle through the frosts of winter. Give it lots of room so that no pruning is necessary - the thorns on this rose demand the utmost respect. Fortunately it is exceptionally healthy and thrives on total neglect.

Seagull (1907)

Yet another great white giant, but this one has slightly more than single flowers for those who like a fuller effect. Like all its kind, it flowers once only, but in great profusion - like a great foaming wave -and is intensely fragrant. Dense grey-green foliage enhances the romantic effect. Wonderful for surrounding a seat in a secluded corner, or training up beside a second-story bedroom window. 9 m. (30 ft.)

Veilchenblau (1910)

Included here for two good reasons: its unusual colour and nearly thornless stems. The trusses of semi-double flowers are violet with streaks of white, and fade to a dusky twilight blue. Small, healthy, emerald-green leaves and a strong, green-apple fragrance add to its charms. This rose teams beautifully with any of the white-flowered varieties. It will tolerate semi-shade which may slightly reduce the number of blooms but intensifies their colour. 4.5 m. (15 ft.)

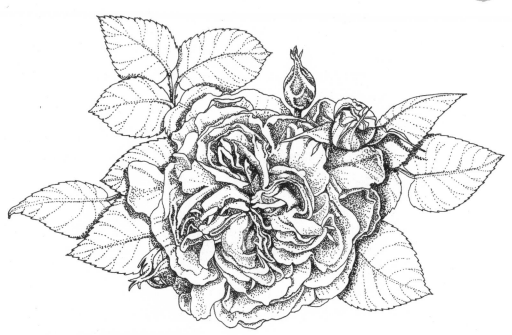

OLD GARDEN ROSES

This is a group of roses that had their heyday in Napoleon's time, when his empress, Josephine, consoled herself as his ardour waned by devoting her time and money to a great collection of roses, and hiring the painter Jean-Paul Redouté to record them for posterity. Their names reflect the dominance of French gardeners in their development and cultivation. The flowers range from a single row of delicate petals to thickly clustered flat and quartered rosettes to full, globular blossoms. The first two of these are better choices for the Pacific Northwest, as globular blooms, temptingly beautiful though they are, do not take kindly to the amount of moisture we generally have to put up with in spring, demonstrating their dislike by rotting rather than opening.

The vast majority of Old Garden Roses are once-blooming, from mid-June to mid-July. A small group, which includes Hybrid Perpetuals and Portland roses, will flower twice, the second time in August or early September, and this information is included in the description where appropriate. Do not let their short season of bloom discourage you from growing them - they are among the most beautiful and fragrant of all roses, and

provide good furniture for the rest of the garden when not in bloom. Many have attractive fall foliage or hips to contribute at a time when other, longer-blooming roses have quit for the year. As a general rule, Gallicas, Albas and Damasks thrive in our climate; Bourbons and Chinas are less happy.

Belle Amour (ancient) Damask.

A thorny shrub with delicate semi-double, sculptured blooms the colour of strawberry icecream, strongly scented of cloves. The petals open wide to reveal golden stamens at the centre. A good crop of attractive round red hips follows the flowers. Grey-green foliage reminiscent of an Alba rose, which some authorities believe it to be. Tall, bushy growth to 2 m. (7 ft.)

Cardinal de Richelieu (1840) Gallica.

Darkest maroon to purple, very double blooms open fold on fold, curving back until the shape is almost spherical and the touch of white at the centre is visible. The individual flowers are sweetly scented and, although not large, come in such profusion that they cover the arching stems. In spring the almost thornless canes are clothed with soft green leaves edged in rosy pink. This is a hardy, easy-to-grow variety which will attain a spread of 2 m. (6 ft.) or more.

Celeste/Celestial (c.1759) Alba.

Blooming in midsummer with blush-pink, well-scented flowers and showy gold stamens, 'Celeste' reveals its Alba origins in its blue-green tinted foliage, which tones so well with the soft colour of the flowers. Strong growth to 1.5 m. (5 ft.) high and wide, and appreciative of a site away from the full glare of the sun, which tends to burn the leaves. The flowers on this rose have an elegant shape, especially at the half-open stage, and the leaves are among the bluest of the Albas.

Celsiana (before 1750) Damask.

Clusters of clear pink, semi-double blooms and grey tinted foliage make a romantic picture in mid-June. This is a "negligée" rose, whose flowers hang like folds of heavy silk on a

tall, open, arching shrub, with a seductive perfume that floats through the air. Benefits from pruning when the flowers are over to keep it from becoming too lanky.

Charles de Mills (c.1840) Gallica.

One of the most spectacular old roses with cupped, deep crimson flowers packed tightly with many petals, and giving the effect of being neatly sliced across to create an even upper surface. As they age, the colour softens to violet and plum, and the petals open to reveal a grass-green button eye. A performer on the show bench as well as in the garden. Dark, coarse foliage on sturdy stems which hold the large flowers well. If grown on its own roots, it will sucker and so is a good choice for a hedge.

Duchesse de Montebello (1829) Gallica.

The pale colour of this rose - a soft, powder-puff pink - is rare in the Gallica family. It makes a neat, compact shrub, well-rounded, of around 1.2 to 1.5 m. (4 to 5 ft.), clothed in apple-green leaves that contrast nicely with the fragrant flowers. So generous in bloom, the flowers cover the bush and weigh down the arching stems. Petals drop before they lose their colour so that at mid-season, the rose appears to be reflected in a pool of pale pink. Can be shaped after blooming to keep its size suitable for the smaller garden; in fact, this is not a bad idea under any circumstances as the leaves tend to go through a ratty period before new shoots revitalize it with fresh green.

Fantin Latour (age unknown) Centifolia.

In general, Centifolia roses don't do well here; rain makes the globular flowers rot before they open and there is a tendency to blackspot, but 'Fantin Latour' is the glorious exception. A large spreading shrub that is so covered in clusters of pale pink, fragrant flowers at mid-summer that they almost obscure the matt, mid-green foliage. It requires a generous amount of space in the garden, and will perform much like a lilac or a viburnum with a sturdy framework of thick branches supporting the more pliant growth above. Once established, it will hold its own in mixed plantings and with some help can even compete with the roots of nearby trees. to 2m (7 ft.)

Hebe's Lip (before 1846) Damask.

An ancient and unusual rose producing sprays of fragile, almost single, ivory flowers tipped with lipstick pink on a thorny, branching shrub. Although ranked with the Damasks, it reveals some Eglanteria ancestry in its slightly scented foliage. When the flowers fade, they are soon followed by a super display of hips like hard, red hazelnuts which hold their colour through into the new year. The leggy lower branches are best disguised behind a screen of low perennials. Upright growth to 1.5 m. (5 ft.)

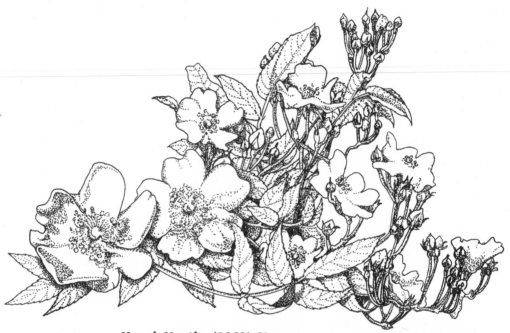

Henri Martin (1863) Moss.

The unusually bright colour and its generosity of bloom have long kept 'Henri Martin' at the forefront of the moss roses. Double, rounded, crimson flowers smother the bush in June. It makes a large, arching shrub that needs some support so as not to collapse under the weight of its bloom. The moss that covers the buds is quite sparse compared with other mosses and the scent is weak for an old rose, but it does make a dazzling display and its health is excellent.

Ispahan (age unknown) Damask.

Nobody knows for sure how old 'Ispahan' really is, only that it had made its way from Persia to Europe by 1832. It is a strong, upright plant capable of reaching close to 2 m. (6 to 7 ft.) and, when mature, requires pruning after it flowers or pegging down of the long canes to keep it manageable. The flowers are rich satin pink and continue to open over 5 to 6 weeks, a longer period of bloom than any other once-blooming rose. They are, like so many Damasks, wonderfully scented. Leaves of crisp green complement the flowers and are exceptionally disease-free.

Jacques Cartier (1842) Portland.

Soft, taffeta-pink flowers, appealing fragrance, neat habit, robust leathery foliage, and the ability to dole out its flowers evenly from summer to first frost - all these attributes make for a very desirable garden plant, small enough to be grown in a half-barrel or anything of similar size. A particular characteristic of the Portland roses is the way the small clusters of flowers nestle on short stems among the foliage, sometimes half-hidden in the leaves, which gives the plant a neatly groomed appearance, but reduces the impact of bloom a little. Oh well, you can't have everything! In the U.S., this rose goes by the name 'Marchesa Boccella' and is listed as a Hybrid Perpetual, although one British authority maintains that the Marchesa is shorter and has a paler flower. A true 'Jacques Cartier' will grow to 1.5 m. (5 ft.) tall.

Macrantha (1823) Unknown origin, possibly a Gallica hybrid.

A rose to be grown as a large, free-standing shrub, or trained in and out of a section of open fence like a living curtain. The fragrant flowers are large, single, and pale pink fading to white with a spray of golden stamens at the centre. A plant in full bloom is a glorious sight, the foliage almost covered by the mass of flowers. These give way to equally as many bright red hips, like hard, round marbles, which last through the winter. Exceptionally thorny, which makes it a good choice for a barrier. If unsupported, young plants produce lax, not to say floppy,

canes; leave them be and they will support the new growth of future years as the plant builds gradually into a huge mound.

Madame Hardy (1832)

Damask. Often hailed as the most beautiful white rose in the world, 'Madame Hardy' has a formidable reputation to defend. And the flowers are heartbreakingly beautiful, opening from shallow cups into flat, snow-white layers of petals, as pure as anything in the garden, surrounding an apple-green eye. Like all the damasks, it has a heady scent, here infused with a bittersweet lemon tang. It can be slow to get going, especially if it is growing on its own roots, but is well worth a little patience and will eventually develop into a good-sized shrub with a height and spread of about 1.5 m. (5 ft.) ; prune it down to about 1 m. (3 ft.) after flowering if it is getting out of hand.

Madame Plantier (1835) Alba.

A rival to 'Madame Hardy' in the beauty and purity of its milk-white flowers, but a more vigorous grower and best suited to growing on an open fence or trelliswork - treated as a small climber, in fact. My own plant envelops a section of farm-wire fence and weaves through an early-flowering viburnum, giving the latter a second season of glory. The fragrant blooms open from buds in a surprising shade of raspberry pink, which often deludes people into thinking they've bought the wrong plant. Light green, healthy foliage and almost thornless stems.

Manning's Blush (before 1799) Eglanteria.

Opinions are divided on which of the Eglanterias makes the best garden plant, and the original parent is in itself a contender, although liable to outgrow any but the largest garden. This variety is not a small plant either, easily reaching a circumference of 1.8 m. (6 ft.), but I think it's one of the prettiest in the group. Clusters of delicate, blush-white flowers are scattered liberally among the fern-like, misty blue-green leaves in a romantic blend of pastel hues. Fragrance, like most of the Eglanterias, is stronger in the leaves than in the flowers, and at its most pungent after a shower of rain, when the air is infused with a scent of apples. Rubbing a leaf between the fingers

releases more of this distinctive aroma. The naturally neat bush requires little pruning, other than to keep it within its allotted space, a worthwhile precaution as the wiry stems are well endowed with fierce little prickles.

Mutabilis/Tipo Ideale/Rosa chinensis mutabilis (1894) China

The date on this rose indicates its first known appearance in the west. In its native habitat in China it is likely much older. A most unusual rose, it has widely-spaced, small, single flowers which begin as vermilion buds and open to a pale buff yellow, changing to pink and finally to crimson before the petals fall. In full bloom it has been compared to a flight of butterflies. Few old roses flower so continuously - cold weather merely turns the buds a paler hue and, although they don't then open, they remain fresh-looking on the bush for weeks. It hates cold wind, but will take a surprising amount of shade, forming an open, leafy shrub with soft red stems and red-tinged foliage, impervious to disease.

Reine des Violettes (1860) Hybrid Perpetual.

Many of the Hybrid Perpetual group compromise their repeat-blooming appeal by their indifferent-to-miserable health. Lovely flowers, terrible blackspot! 'Reine' stands out for her better health and the gorgeous, deep violet allure of her large, shapely flowers, with a perfume to die for - a 1930's movie star of a rose. As the petals age they soften to lavender and grey, blending with the grey-green of the foliage. The thornless stems grow very upright and need careful pruning to avoid a twiggy, untidy, bare-legged look. Cutting back harder than usual every three or four years encourages sturdier growth. A classic rose, in bloom from summer to late fall, and considered by some to be the rose most nearly blue in colour.

Rosa glauca/Rosa rubrifolia (before 1830) Species.

More like a small, multi-trunked tree than a shrub, this rose is the landscape designer's dream plant, not so much for its flowers as for its graceful arching frame and its beautiful dusky blue leaves outlined in tints of purple and plum. When it bears

its small, single flowers in June, they spangle the foliage like cerise-pink stars. Autumn sees it decked in clusters of round, shiny red hips, slowly darkening to black. Even in winter, the bare branches are a subtle shade of burgundy dusted over with grey. A free-standing feature for any garden, rising to about 2.5 m. (8 ft.).

Rosa Mundi/Rosa gallica versicolor (before 1581) Gallica.
A legendary rose, this is the oldest and best known of the striped roses. The flowers are semi-double, the petals varying from white streaked with crimson to crimson streaked with pale pink and white- a much more attractive combination than it sounds - and are followed by oval, orange hips. It has a rather rambling growth habit, producing many wiry, almost thornless stems with coarse, dark green foliage. Not very scented, unlike its parent 'The Apothecary's Rose' (Rosa gallica officinalis), which has single crimson flowers with gold stamens and is particularly good for potpourri, as its petals hold their fragrance when dried. The variegated version has a habit of reverting to its parent; if this happens, cut out at the base the stems bearing solid crimson flowers or you'll end up losing the variegated ones entirely.

St. Nicholas (1950) Damask
An Old Garden Rose hybrid discovered in the garden of the same name, owned by Bobbie James, whose own name is preserved in a very different rose, 'St. Nicholas' offers a truly beautiful, almost single flower of glowing pink with a central crown of golden stamens. Soft, greyish foliage sets off the blooms to perfection. The round, nut-like hips are among the reddest and longest lasting of any, still colourful as the new year arrives. A thorny but compact plant which would grace even a small garden, and look well in a large stone container.

Stanwell Perpetual (1838) Pimpinellifolia
A significant rose, most notably for its characteristic of blooming throughout the season. Not quite as perpetual as its name would suggest, it flowers in bursts with the odd bloom in between - pretty, dishevelled, pale pink flowers opening flat and

fading almost to white as they age. Growth tends to be sprawly, the thin canes are covered in vicious little prickles, and the grey-tinted, fern-like leaves develop a curious purple discoloration which looks like disease but isn't. These drawbacks, such as they are, are overcome by the willingness of the plant always to put out more flowers, by its health, and by its hardy constitution.

Tuscany Superb/Superb Tuscan (before 1837) Gallica.

Lovers of deep red velvet, here is your rose. Exquisite in shape, unmatched for richness of colour, and scented as such a rose should be, 'Tuscany Superb' lives up to its name. Each long-stemmed almost-double flower unfolds to a flat, perfectly symmetrical disc revealing the glowing golden stamens at its centre. Variable in habit, plants may be tall and upright, low-growing, or occasionally lax and flexible.

William Lobb/Old Velvet Moss (1855) Moss.

The most opulent of the moss roses, 'William Lobb' bears dark crimson and lavender flowers with a dusky texture and fluctuating colour like shot silk. It makes a tall, leggy shrub, not particularly attractive unless fanned against some kind of structure with other plants around its base to cover its bare shanks. The flowers bloom in clusters of three or four, and have a quality that can only be described as "Mae West", drawing murmurs of appreciation for their seductive charm. The moss on young stems and the buds is bronze-green and very pungent. More modest moss roses include the little, pearly white 'Alfred de Dalmas', well-scented and repeat-blooming, and the wine-red 'Nuits de Young' which, given time, makes a prickly, impenetrable thicket of wiry stems.

MINIATURE ROSES

A relatively modern introduction, dating from the discovery of the original, a mutation of a China rose, in 1922, miniature roses have provided a way for people whose only garden is a collection of pots on a balcony to grow roses, too. They can also be grown in a regular garden, but need careful placing if they are to avoid looking too fussy. The flowers come in all the shapes and colours of big roses, but very few are scented, and disease is more prevalent in these little roses than you might expect. On the other hand, they are prolific and continuous bloomers and, being almost always grown on their own roots, are also extremely hardy, more so than many larger roses; they will spring back to life even after enduring winter in an unprotected pot, provided that the soil did not freeze all the way through. An unfortunate recent trend has seen these little roses increasing in size to the point that the flowers look out of proportion on the dwarf plants, but many of the most charming older varieties are still easy to obtain. There are a number of climbing varieties, which have a miniature flower but will reach a height of 2.5 to 3 m. (8 to 10 ft.); the best of these are included in the section on Climbing Roses.

Beauty Secret (1965)

Thirty years old and still one of the best. Cardinal-red, classically-shaped blooms look elegant in bud and open flower and are quite fragrant. Glossy, patent-leather leaves enhance the bright colour of the flowers. Neat growth habit.

Cinderella (1953)

Tiny white flowers with pink edging like candy roses made of spun sugar sprinkle the vigorous bushy plants. One of the older minis and one of the hardiest in spite of its fragile appearance. The twiggy, nearly thornless stems have tiny leaves to match the little flowers.

Cupcake (1981)

Everybody likes the shape of this rose, whose neatly overlapping, pointed petals look almost too perfect to be true, just like cupcake icing with stamens like a dot of lemon jelly in the centre. The colour, a particularly dense and even pale pink, is reminiscent of a '55 Cadillac. Strong, healthy growth and unflagging bloom production throughout the season. A good choice for a low hedge.

Golden Beryl (1995)

Raised by amateur hybridizer George Mander in British Columbia's Fraser Valley, this is a bushy, compact garden plant with the shape and substance to be an exhibitor's delight. Flowers are like tiny Hybrid Teas in a rich shade of unfading yellow. Another Mander introduction, 'Glowing Amber', is too new to assess for its garden performance but has made a major initial impact in U.S. and U.K. shows, admired for its form and its unusual colour - red velvet on the upper side, golden yellow on the underside.On its first appearance in an English show, people asked whether it was real or made of porcelain china.

Gourmet Popcorn (1986)

The name says it all - little white rounded flowers with yellow centres scattered profusely all over a vigorous plant which will grow to 60 cm. (2 ft.) all round. One of the few miniatures with a discernible scent, reminiscent of honey.

Green Ice (1971)

My favourite among the miniatures for the striking contrast of glossy, dark green foliage framing clusters of pure white flowers that take on tints of chartreuse and frosty pink as they age, a characteristic made more intense if it is grown in semi-shade. It makes a bushy, lax-stemmed plant which will tumble effectively out of a hanging basket, but also blends well into the larger garden as an edging plant for a border. Needs good air circulation and a regular feeding program to ward off mildew.

Little Artist (1982)

One of the "hand-painted" roses, this is a vigorous, bushy plant, absolutely covered in cheery little blooms, and lends itself well to use along the edge of a border. The flower is single with petals of clear red accented by brushtrokes of white and a centre filled with bright yellow stamens. Young leaves have an unusual look but develop normally. One of the best miniatures for vitality and impact.

Loving Touch (1983)

Beautifully furled, slim buds of tender apricot open into high-centred flowers of softest peach. The blooms are long-lasting in water, making this rose popular with flower arrangers and exhibitors. The plant is somewhat on the tender side - grow it in a pot and give it shelter over the winter.

Minnie Pearl (1982)

Very double, pale pink blooms of classic Hybrid Tea shape keep this hardy rose flowering over a long season. This is another popular show rose, the elegant flowers enhanced by long stems and good keeping qualities. Slender, pointed buds look stylish in a buttonhole.

Opening Act (1994)

A deep red single flower with golden stamens, rather like a miniature version of 'Altissimo' (q.v.) Each rounded petal narrows to a distinct point like an ace of hearts, and has a gentle undulation that sets it not quite flat against its fellows, giving the flower an ever so slightly rippled effect. Holds up surprisingly well as a cut flower, too.

Pink Petticoat (1979)

Easy to grow and generous in bloom, this miniature grows vigorously to a height and spread of about 60 cm. (2 ft.). Attractive flowers are a blend of cream and soft coral. It has the unusual characteristic for this class of producing hips, and sizeable ones at that.

Rainbow's End (1984)

A popular miniature among those who like flowers in vivid colours -vermilion, orange, amber, gold - the colour is ever-changing. The bush is neatly rounded with sturdy stems and dark leaves, and is always in bloom throughout the summer months.

Reiko (1995)

Among the few miniatures with scent, this one recalling the old Tea roses. The flower is a clear pink, nicely shaped. One of several good miniatures from Fraser Valley hybridizer Brad Jalbert, 'Reiko'made it into the top ten in the Canadian Rose Society's 1997 miniature ratings.

Sandalwood (1995)

Imagine the patina of a weathered terracotta pot and you'll be close to grasping the unusual colour of this rose. The shapely flowers are large for the wiry stems, making this perhaps more of a patio rose than a true mini. The plant is tender and prone to disease, but is included here because there's no colour quite like it.

Snow Bride (1982)

A miniature of beautiful shape, like a tiny Hybrid Tea rose. Furled white buds open into a perfect circle with a pointed centre, and there is even a little scent. Makes a nicely rounded little shrub well covered with dark green, disease-resistant foliage and will grow to about 30 to 35 cm. (12 to 14 in.)

Snow Carpet (1980)

Unlike most of the other roses in this section 'Snow Carpet' is a true groundcover, spreading wide and densely over close to a metre (3 ft.) of ground. A generous scattering of tiny white flowers on short stems studs the tiny, grass-green leaves. Not a good rose for picking, obviously, which may be why it hasn't received more notice, but superbly healthy and great as an underplanting or edging for a border.

Sweet Chariot (1984)

One of the most scented mini roses, which is recommendation enough, but its large, loose clusters of grape and blackberry-coloured flowers with a touch of cream at the centre are beautiful to look at as well. Long arching stems make it ideal for cascading out of a basket or urn. Hardy and disease-resistant, too. An excellent miniature for the average garden for all these reasons.

NOTES

3 ROSES FOR SPECIAL PURPOSES

There are occasions when a rose is required to have more than a good colour, lots of bloom and a reasonable health record. For some people, roses are synonymous with scent and choosing one without this characteristic is unthinkable. An increasing number of gardeners who are making fall and winter interest a priority often have a hard time finding information on this aspect of roses in the existing literature. People with limited space, or a shady garden want to know if there are roses to suit these conditions. Certain circumstances demand a thornless rose, others quite the opposite. Under the following headings, you will find roses grouped by attributes which make them particularly suitable for a specific role in the garden. Some of the same roses appear in several categories and, while this may have something to do with my own biases, I prefer to think that it is because they are such adaptable, garden-worthy varieties.

Roses for Fragrance

Hand someone a rose and the first thing they will do is hold it up to their nose to smell the perfume. Roses have had that reputation for thousands of years, even though in the last century much of the breeding has been for size and colour at the expense of scent. However, while many modern roses have only what the catalogues call "slight scent"—meaning hardly any— there is still a good choice available for those who feel that a rose without a perfume is not a real rose. Many of the old fragrant roses of the past are enjoying another bout of popularity, too, and the English roses bred by David Austin have introduced a strong new perfume, usually described as "myrrh", although it is not to everyone's liking.

Most of the old garden roses are well-scented. It's sometimes an elusive fragrance in the garden, but strong and heady in a bouquet cut and brought inside. Among my favourites are the deep purple Gallica 'Cardinal de Richelieu' and the pink Damask 'Ispahan'.

Most of the big ramblers are well-scented, too, enough to pervade the whole garden when they are in full bloom. 'Seagull' is particularly fragrant, as well as beautiful, and so are 'Wedding Day' and 'Rosa mulliganii'. 'Adelaide d'Orléans' smells of primroses and the climber 'City of York' like orange blossom.

The above are all summer-blooming roses. Among those that give a second flush of blooms in fall, my first choice would be 'Reine des Violettes', a Hybrid Perpetual rose of great beauty as well as perfume. Hybrid Musks, such as 'Penelope', 'Felicia' and 'Lavender Lassie' offer the scent of lilacs long after lilac time

Another repeat-blooming rose, a climber with deep, red velvet petals and a fragrance to match, is 'Souvenir du Dr. Jamain'; alas, this is not a healthy rose in our part of the world, being very prone to blackspot, and inclined to burn in too much sun. Still, many of us who have it in our gardens willingly put up with its deficiencies for the beauty and rich scent of its blooms. For beauty as well as fragrance, my favourite climber is 'Madame Alfred Carrière', one of the few Noisette roses to be hardy in our climate. The blush pink to cream flowers have a strong scent with a lemon tang that is never cloying. Although somewhat prone to mildew in the fall, 'Madame Alfred' is strong enough to shake it off without any noticeable diminution in vigour..

Among modern roses, 'Fragrant Cloud', a tomato-red Hybrid Tea, with an almost overpowering scent has long held first place in the fragrance sweepstakes . 'New Zealand', with a pale pink flower which blends more easily into a mixed garden, is a recent challenger for the crown. 'Sheila's Perfume', a vivid golden and red blend which lives up to its name, is another good choice for our climate. For those who like soft sunset colours, 'Rosemary Harkness' has a satisfying fruity scent. Then there is 'Double Delight', which I hesitate to mention because it is not a strong grower and suffers from rather too much disease, but the cream and raspberry flowers are so beautiful and the scent is so sweet that it has many admirers willing to overlook its health record. 'Margaret Merril' is a fragrant choice for a white rose, although it too has questionable health.

Among yellow roses, 'Sutter's Gold' has a lovely perfume but is not a very vigorous variety; choose the climbing form if

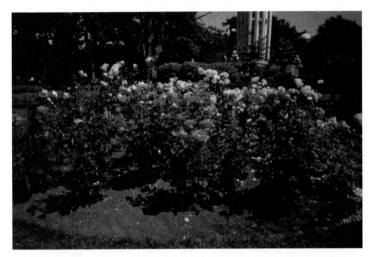

(Above) A formal rose garden.
(Below) Roses in a mixed border.

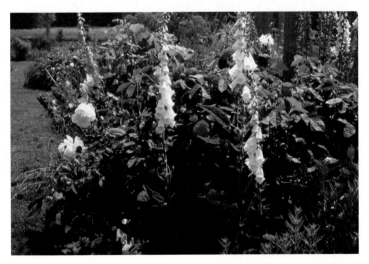

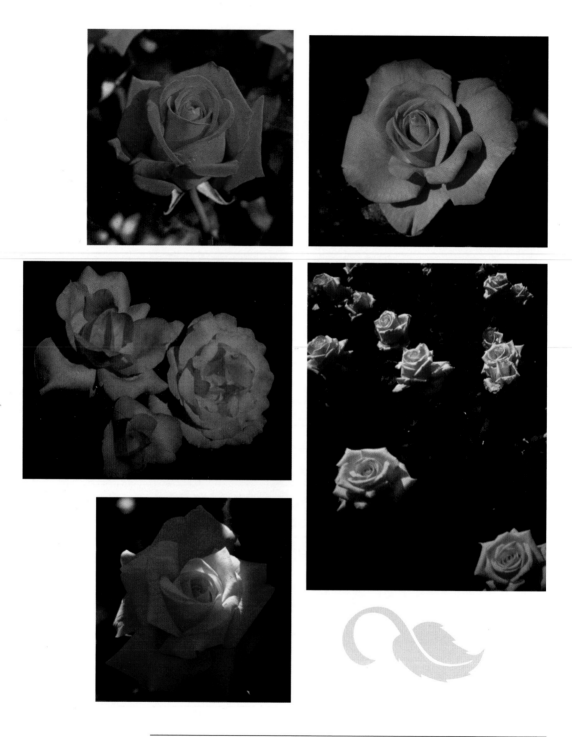

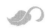

(opposite, clockwise from top left)
Hybrid Tea Roses: Loving Memory,
Paradise, Savoy Hotel, Chicago Peace,
Elina.

(this page, clockwise from top left)
Hybrid Tea Roses: Election, Ingrid
Bergman.
Floribunda Roses: Sexy Rexy, Tabris

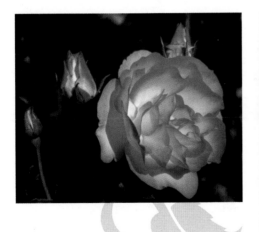

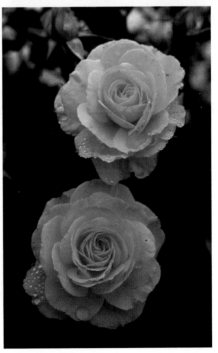

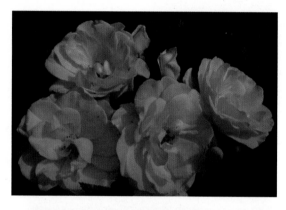

Floribunda Roses:
(clockwise from below)
Glad Tidings, Fellowship,
Lavaglow, Playboy, Iceberg.

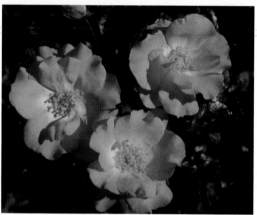

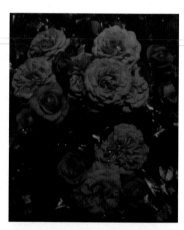

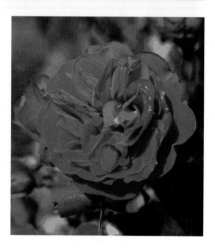

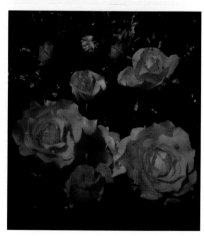

Shrub Roses:
(clockwise from right)
Abraham Darby, Blanc Double
de Coubert, Buff Beauty,
Penelope with Sally Holmes in
background,
Bonica (left) with Ballerina.

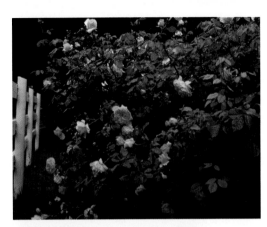

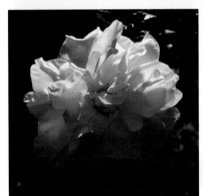

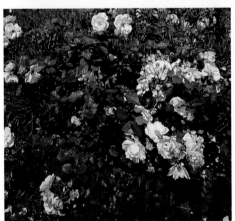

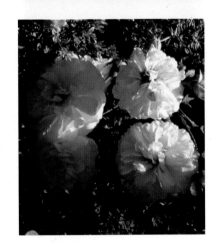

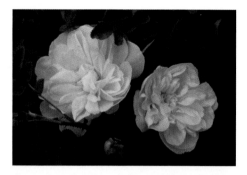

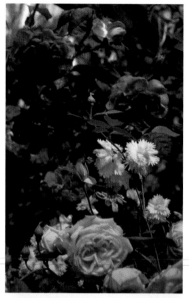

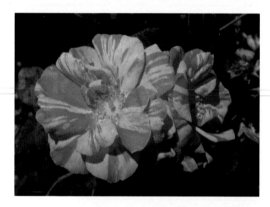

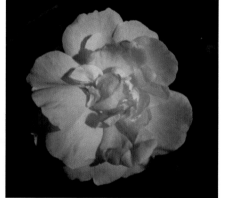

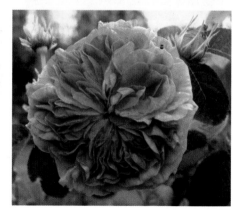

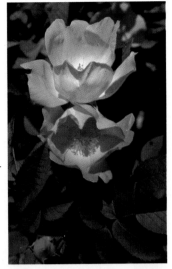

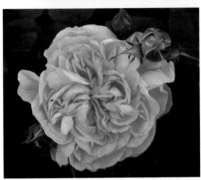

Old Garden Roses:
(opposite, clockwise from top left)
Stanwell Perpetual, William Lobb
above a pink China rose, Celeste,
Charles de Mills, Rosa Mundi,
Rosa Mundi flower; (above left)
Complicata, (below left) Fantin
Latour, (above right) Reine des
Violettes.

(Right)
The small rambler
Ghislaine de Féligonde.

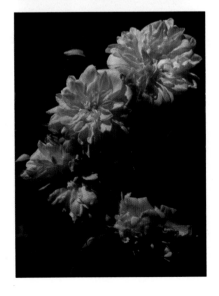

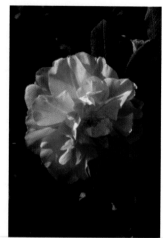

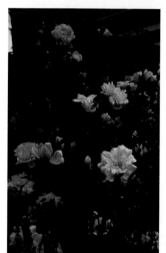

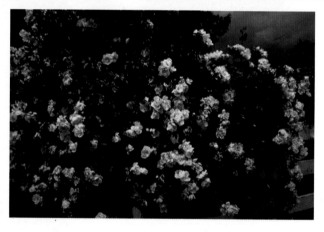

Climbers and Ramblers:
(clockwise from bottom left)
New Dawn, Albertine,
Dublin Bay, François
Juranville, City of York.

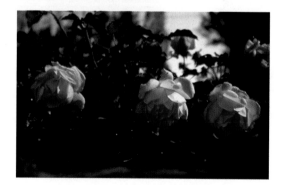

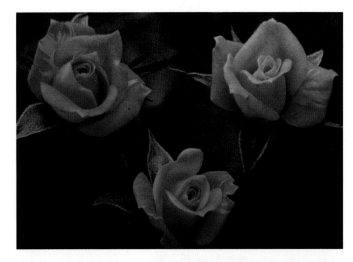

Miniature Roses:
(clockwise from right)
Golden Beryl, Opening
Act, Warm Welcome.

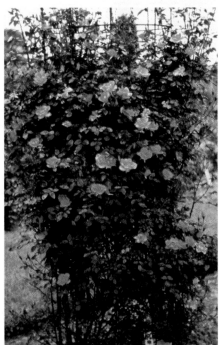

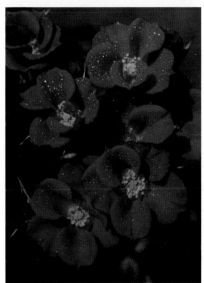

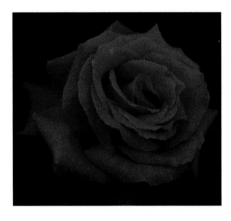

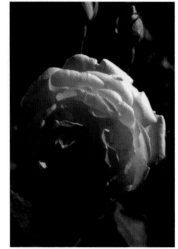

Roses for Fragrance:
(clockwise from above)
Fragrant Cloud,
Mme. Alfred Carrière,
Rosemary Harkness,
Double Delight,
Adelaide d'Orléans

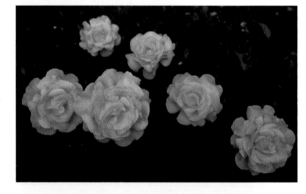

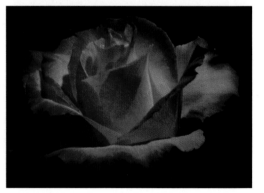

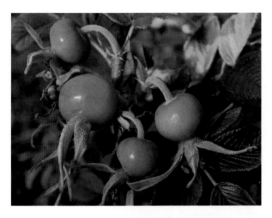

Roses for Hips:
(clockwise from below)
Scotch Briar, St. Nicholas,
Rosa moyesii 'Geranium,'
Fru Dagmar Hastrup.

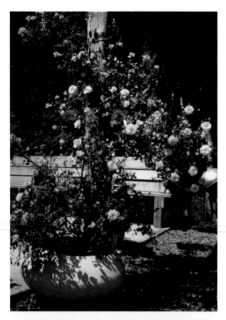

Roses in Containers:
(left top) Jeanne Lajoie,
(left bottom) Sandalwood.

(Below) Green Ice as a Standard.

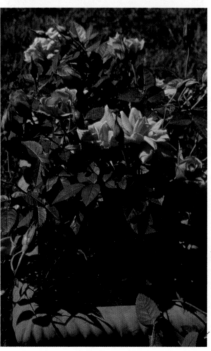

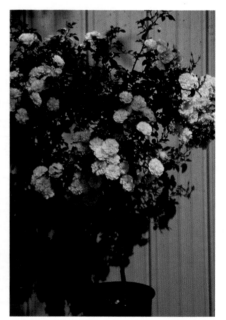

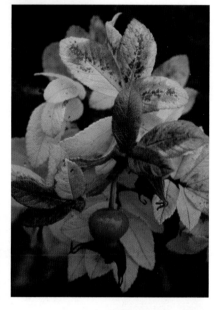

Roses for Fall Foliage:
(above) Rosa mulliganii,
(below) Thérèse Bugnet.
(right) A Rugosa rose.

Rugosa
rosehip in
winter.

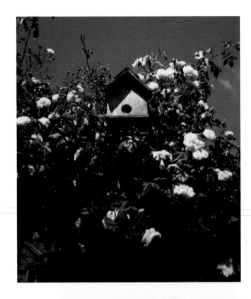

Roses as Security Devices:
(clockwise from bottom left)
American Pillar, Félicité Perpétue,
Macrantha.

(Below) Leander on an arch.

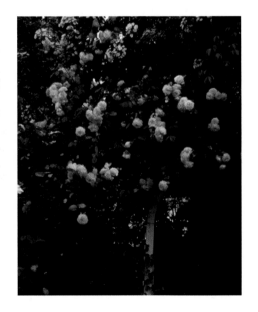

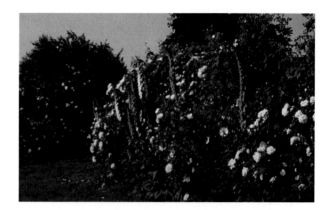

(Above) A hedge of mixed roses.

Roses as Specimen Plants:
(left) Carmenetta,
(below) Duchesse de Montebello.

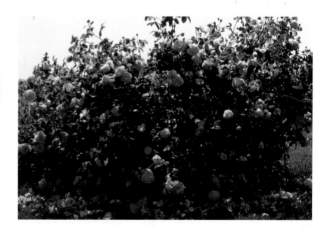

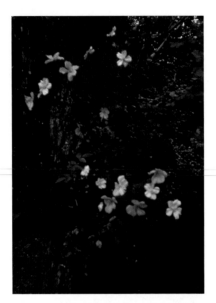

(Left) Mutabilis,
a rose for a shady place.

(Below) A hedge of native
roses in winter.

possible and be prepared to give it some winter protection. 'Graham Thomas' is one of the most popular of the Austin shrub roses, and to many noses has a more appealing scent, reminiscent of the old tea roses, than most of its group. For a really strong tea scent, the old favourite 'Climbing Lady Hillingdon' is exceptional, but it is tender this far north, and will need your sunniest, most sheltered corner to do well.

Few miniatures have any scent to speak of. The trailing 'Sweet Chariot' is an exception, and 'Lemon Delight', a miniature moss rose, smells appropriately citrus-like. 'Reiko' , a recent introduction, is pretty, pink and perfumed. Among the miniature climbers, 'Laura Ford' combines a gentle fragrance with attractive yellow blooms.

Before leaving the subject of fragrance, it is worth mentioning the small group of roses that exude their scent through their leaves rather than their flowers. This specifically applies to the Sweetbriar, Rosa eglanteria, a tall, rambling shrub with small pink single flowers in early summer. Although the flowers have no discernible smell, the leaves diffuse their apple-like aroma across a garden, especially after a shower of rain. 'Lord Penzance' and 'Lady Penzance' inherited this characteristic, and are more manageable choices than their species parent for a modest garden, though not as healthy. Best of all, in my opinion is the much under-rated 'Manning's Blush', with small, blush pink rosettes of bloom in summer and fern-like leaves of a soft grey-green which are almost as aromatic as those of its wild parent.

Other Fragrant Roses: Baronne Edmund de Rothschild, Portrait, Friesia, Radox Bouquet, Buff Beauty, Chinatown, Gertrude Jekyll, Constance Spry, Compassion, Etoile de Hollande, New Dawn, Sombreuil, Lykkefund, Wedding Day, Belle Amour, Hebe's Lip, Beauty Secret, Gourmet Popcorn.

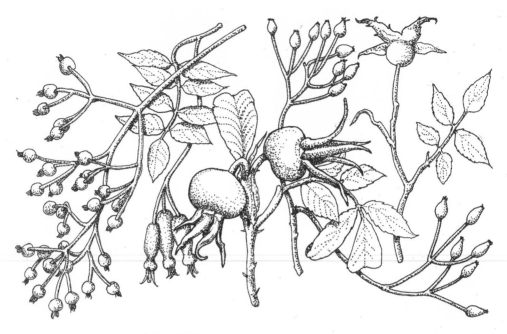

Roses for Hips

Hips, or heps, are the fruit of the rose, the means by which the plant follows the dictates of nature and seeks to ensure the survival of its species. It is hardly surprising that wild roses and their near relatives are responsible for many of the best displays of hips. Modern hybrids, on the other hand, rarely set hips, their energy being channeled into making bigger flowers for a longer period of time.

Of course, hips are a secondary consideration to flowers, and few people are going to choose a rose for this feature alone. But for adding winter interest to the garden, not to mention attracting birds, there are few plants that can make such a valuable contribution. These are the roses that you must refrain from pruning after the petals drop in order to encourage the maximum winter display.

The largest, roundest hips belong to some members of the Rugosa family, that tough group of roses that do well even in extreme conditions, although their fruits are too soft to be among the longest lasting. 'Rosa rugosa rubra' and 'Rosa rugosa alba' both produce good hips like shiny red crabapples. Among their hybrids, one of the best is 'Fru Dagmar Hastrup' (or

Hartopp) which follows its silvery pink, single flowers with what looks like a crop of cherry tomatoes. 'Hansa', which grows larger and has a semi-double magenta flower, has similar but fewer hips. Both these roses will continue to produce flowers alongside their hips until late in the year, when their leaves provide a backdrop of russet and gold as an additional bonus.

Clusters of large, flask-shaped hips that cover the bush and create a vivid winter display make the tall shrub Rosa moyesii 'Geranium' a winner. This is a good rose to plant at a focal point of the garden, as it stands up without support and has two strong seasons of interest when you include the bright, single flowers that smother it in June/July and by their colour give it its name. Don't prune it, though, as it is one of those plants that develops strong canes which thicken like saplings over several years to provide a sturdy framework for the flower-bearing branches.

Most of the species roses, including the ramblers, will give a good crop of hips in fall, ranging from the sprays of tiny orange beads that ornament a rose like R. mulliganii, through the round, boot-black currants of R. pimpinellifolia, to the hard, crimson marbles of R. gallica versicolor. 'Hebe's Lip' also produces a heavy crop of round hips, as does 'St. Nicholas', which is perhaps my favourite because its bright red berries last so long —right through the winter. The brightest, shiniest berries of all belong to Rosa eglanteria.

Among more modern roses, the shrub 'Golden Wings' produces large, pale green hips, and 'Bonica'—that all-purpose, useful shrub rose—has round orange fruits that brighten the garden all the way through to February. 'Penelope' — in my opinion the best of the Hybrid Musks — also has good hips, aging from pale green to carrot-coloured over a period of months.

When it comes to climbers, few have any energy left for hips, since they have been required both to make growth and to flower all season. 'Dortmund' is one that bears fruit, but it will flower again if pruned back, which everyone prefers. However, leaving the end-of-season blooms to form hips is worth considering. The options then come down to once-blooming climbers, and here 'Madame Grégoire Staechelin' is unbeatable, attracting attention first with its large, ruffled pink blooms in

summer, then with hips like green marzipan pears, which gradually turn an intriguing shade of pale pumpkin by the turn of the year.

Other Roses for Hips: Darlow's Enigma, Belle Amour, Rosa macrantha, Rosa gallica officinalis, Rosa doncasterii, Scharlachglut (Scarlet Fire), Pink Petticoat.

NOTES

Roses for Containers

Almost any rose can be grown in a container if the container is large enough. For practical purposes, something around the size of a half barrel will hold a good-sized shrub rose, provided that you are willing to haul it out and prune the roots once every three to four years. I know one gardener who is even growing the rampant climber 'Madame Grégoire Staechelin' in half a whisky barrel, which so far doesn't appear to be cramping its style at all. Nonetheless, there is more chance of getting a full measure of satisfaction from a rose whose size is easily accommodated in the chosen container.

That said, don't try to grow any rose, even the smallest in a container less than 30 cm. (12 in.) in diameter; for one thing, they do need to be able to spread their roots, and for another, small containers dry out so very fast, especially in summer. More than anything else, roses like to have a moist root-run.

Miniature roses are the obvious first choices for container growing. Some, like 'Sweet Chariot', already mentioned for its fragrance, lend themselves particularly well to festooning a hanging basket. My favourite miniature for any type of container is the healthy and adaptable 'Green Ice', which will comfortably fill out the space with its glossy leaves and cool, fresh-looking flowers. For a dramatic display, you might choose 'Sandalwood', whose large flowers with their unusual colouring, just the shade of a terracotta pot, draw attention wherever it is grown. Give it greenhouse protection over the winter, though.

Climbing miniatures are an excellent choice for a large container backed up by a wall or trellis to which they can be attached. They can reach the top of a doorway quite comfortably if they are given the chance. 'Jeanne Lajoie', a pink miniature with a very generous habit of bloom, can flank a doorway from top to bottom at maturity. For drama, choose 'Warm Welcome' with its combination of purple-tinged foliage and mandarin orange flowers. 'Nozomi', which is sometimes listed as a miniature because of its tiny pink flower and sometimes as a shrub because of its size and spread, looks wonderful in an urn where its trailing arms can dangle gracefully over the edges; if it has enough room, it will extend easily for a metre (3 ft.) or more, like a living curtain.

Some of the smaller shrub roses cope well in a confined space. 'The Fairy' is free-flowering and disease-resistant and it can put up with more demanding conditions than most roses, even enduring a considerable degree of cold in winter without extra protection for its roots. All the Meidiland series are equally hardy and would be at home in a confined space. 'Ballerina' and its look-alikes in other colours flower so generously and have such a bushy habit of growth that they look superb in low planters, particularly of white-painted wood or grey stone.

Most of the Hybrid Tea roses have an upright, angular shape that, to my mind, does not look especially attractive in a container, but some of the smaller Floribundas would be worth experimenting with. The compact size of 'Double Delight' should allow you to enjoy its pretty flower and rich perfume on the patio, and it may be easier to keep an eye on its health this way, too. The same goes for 'Margaret Merril'.

Among the Old Garden Roses, the group known as Portland roses has the twin advantages of compact size and a repeat-flowering habit. 'Jacques Cartier' is pretty, ruffled pale pink, 'Rose de Rescht' a vibrant crimson. 'Comte de Chambord', another pink, is beautifully formed and has a rich fragrance as well. Any would grace a large container, and they have the advantage of a naturally neat shape, because the flowers sit on very short stems, just level with the foliage.

Although they flower only once, in early summer, I like the idea of Pimpinellifolia roses in containers, especially if they are growing on their own roots. This family spreads by countless wiry suckers, and would fill the allotted space in a short time. When they become potbound, they are easily divided, just as you do with herbaceous perennials. Their habit of flowering all down the stems in a bridal bouquet fashion, is particularly graceful, and although they bloom for a month at most, they follow with attractive mahogany hips; or they can be quietly tucked away in a hidden corner and forgotten until next year, being hardy enough to survive without protection in all but the harshest winter. Among the prettiest are the parent species 'Rosa pimpinellifolia', which has pale primrose, lemon-scented single flowers, and 'Mrs. Colville', whose crimson flowers with a white eye are set off by dainty, fern-like, grey-green leaves.

Other roses for containers: Fragrant Cloud, Royal William, Trumpeter, Friesia, Lavaglow, Flower Carpet, Dart's Dash (a low-growing version of Hansa), Fair Bianca, all miniatures.

NOTES

Roses as Specimen Plants

It always surprises me that, while people will happily make a feature in the middle of a lawn or the centre of a bed with a lilac, say, or a rhododendron, few consider using a rose for this purpose. There are roses that grow as tall, bloom as long and smell as good as a lilac, and there are roses that grow as large and flower as vividly as a rhododendron. The right rose will also provide colourful fall foliage and bright hips to enliven dull winter days. Granted, roses are not evergreen, but on a frosty winter morning, when every prickle on a rose glitters like a diamond, can a rhododendron's drooping, drab green leaves, scalded with brown spots, really compare?

Landscape designers, who value foliage and structure as much as they do flowers, are very partial to Rosa glauca, which used to be called Rosa rubrifolia. It makes a free-standing bush of about 2.5 to 3 metres (8 to 10 ft.) when fully grown, never gets disease, and requires pruning only to shape it or to cut out some of the old wood every few years. This rose has soft blue foliage, tinged purple at the edges. When it blooms in June, the effect is like a shower of tiny pink stars, and in fall, the shiny red beads of its hips dangle from every branch. There is a Canadian-bred hybrid of R. glauca, called 'Carmenetta' which grows even larger and has larger flowers, although the foliage is not quite such a dusty blue and it sets few hips. Both these roses are exceptionally hardy.

Rosa moyesii 'Geranium', already mentioned for its eye-catching hips, is another tall, self-supporting rose, with vivid red flowers.

For a big mound, there is the shrub rose 'Nevada' with large single flowers of creamy white, which appear all along the canes. At its best a dazzling sight, but it can be finicky and not altogether healthy in our climate. Not quite as dramatic in flower, but more reliable, is the Rugosa rose 'Blanc Double de Coubert'. It can be rounded by pruning, or left to grow into a tall vase shape. The fragrant flowers start early in the season, in May, and look like fragile white camellias. The bush continues to flower till fall, when the leaves turn a rich gold. There is a drawback: it does not shed its spent petals, which turn an

unattractive paper-bag brown, especially in wet weather. Constant deadheading is the solution, contributing to more blooms as well.

Several others in the Rugosa family also make good candidates for specimen planting. 'Scabrosa', which has bright silvery-pink single flowers with cream stamens, makes a huge mound easily 1.8 cm. (6 ft.) high and more than that wide. Left unpruned, its lowest branches will sweep the ground, eliminating, or at least hiding, weeds underneath and, in fall, large red hips ornament the russet and amber foliage.

Another good white, especially if you like the wild look of clusters of tiny single flowers, is a foundling rose known locally as 'Darlow's Enigma' after the Seattle gardener in whose garden it appeared. Unlike true species roses, 'Darlow's Enigma' is always in bloom, although it retains the scent and the fall hips associated with its wilder relatives. It will need careful pruning to maintain it as a free-standing shrub, or you can give it a support and grow it as a climber. Because it is unregistered in the trade, it is not easy to find but is well worth tracking down.

The best modern rose I know for a specimen plant has to be the superlative 'Sally Holmes', which is billed as a climber in southern states, but rarely achieves that height here. Instead, you can expect a large shrub as wide as it is tall, with spectacular clusters of satin white single flowers opening from buds in a curious shade of chamois tinged with pink. It continues to bloom all season and, if it were scented, would be hard to equal.

Other roses for Specimen Plants: Elina, Eyepaint, Bonica, Chinatown, Golden Wings, Abraham Darby, L.D. Braithwaite, Lichtkonigen Lucia, Charles de Mills, Duchesse de Montebello, Fantin Latour, Manning's Blush, Rosa macrantha.

Roses as Standards

Standard or tree roses have two or preferably three buds grafted around a single strong stem at a much higher level than a normal bush rose, giving the effect of a small tree with a profusion of bloom around the top. It's a very contrived, formal effect, as well as an expensive one, and I'm not a great fan of it, particularly as roses grown this way need extra care if they are to look good — or even survive. However, there are situations where this treatment can create a dramatic impact, and they do provide an extra option for apartment dwellers with large tubs to fill. Just be prepared to spend more time on pruning and winter protection and, if planting in a container, make sure that you use a pot with a diameter of at least 45 cm. (18 in.) to provide stability.

There are two styles of standard roses: the lollipop look or the weeping standard. Different roses are used to create these styles and they are not interchangeable, so if you want a lollipop, you can't buy a weeping form and modify it successfully, and vice versa.

The graft is usually made at a height of 1 m. (3 1/4 ft.), and it is wise to strap the stem to a permanent post (in at least two places, using a strong but flexible material) to help it support the top-heavy load of blooms.Half-standards of 75 cm. (2 1/2 ft.) are occasionally available. Almost any bush or shrub rose can be used for a lollipop but clusters of smaller flowers are usually more attractive than large single blooms like Hybrid Teas, and varieties with a long period of consistent bloom are obviously going to be the most satisfying. 'Iceberg' is a popular choice for standards because it is so prolific. 'Ballerina' and 'The Fairy' are among the smaller shrub roses often used this way. Miniatures are often the best choice of all because they respond so well to the careful clipping required to keep the symmetrical shape. 'Green Ice' would be a natural for this use, and 'Little Artist' would be dazzling. From a design point of view, lollipops look best in multiples: a pair flanking a doorway or a row defining the edge of a curving path.

Weeping standards are sometimes taller than lollipops, allowing the canes to trail gracefully in an umbrella shape from the central stem. Roses with naturally flexible canes obviously

come into their own here: for example, the vivid and generously flowering 'Flower Carpet' or the Miniature 'Sweet Chariot'. Any of the climbing Miniatures would also be effective.

For this particular use, I hesitate to give more recommendations. The bottom line is that standards are not readily available in the nursery trade and, unless you are willing to do your own grafting, you may not have a choice of which rose you get.

NOTES

Roses for Moonlight

Ever since Vita Sackville-West planted her white garden at Sissinghurst and told the world about it, gardeners have been making their own versions on every possible scale and terrain. Beautiful by daylight, these silk and silver landscapes really come into their own after dusk has fallen, when they shimmer in moonlight like perfume become visible—because, of course, you've chosen them for fragrance as well as colour.

Ramblers are best at making their presence felt in the evening because of their size and the sheer quantity of their perfumed flowers. Central to Ms. Sackville-West's scheme is Rosa longicuspis (or Rosa mulliganii, according to some sources) which drapes an arbour with its masses of tiny flowers in midsummer, and fills the air with its strong, heady scent, even more intoxicating at night than by day. 'Wedding Day' or 'Bobbie James' will cover just as much space and be just as fragrant. So will 'Seagull', which has more petals to each flower and looks like a great foaming wave when it is in full bloom.

A chance seedling, discovered in a Danish garden and named "lucky find" gives us all the virtues of the above ramblers and is in addition thornless: `Lykkefund' is thus a good choice for an arbour or beside a footpath, where you can linger to enjoy its ivory flowers and sweet scent without the risk of being hooked by an aggressive tendril.

My personal choice for pride of place on our verandah, where its perfume can filter in through the open windows or waft over us as we sit outside on warm summer evenings, is 'Madame Alfred Carrière', whose loose clusters of pearly white flowers have a lingering perfume recalling orange blossom, apples and gardenia. 'Madame Alfred" is also tolerant of some shade, which means you can plant it on the north side of the house and watch it climb towards the sunlight.

Most of the old Tea roses, with their characteristic spicy scent, are not really hardy enough for this climate, but 'Sombreuil' is something of an exception and survives reasonably well on a pergola in my exposed and windy, zone 7 garden. The creamy white flowers, like pompoms on a wedding

car, do smell somewhat like the very best Earl Grey tea. This climber has a good repeat bloom, too.

Among the bush roses, Rosa pimpinellifolia flowers in fronds of single blossoms, pale yellow turning to white, and infuses the surrounding air with the scent of primroses. It flowers earliest of all in my garden, in full bloom by the end of May, and spends the rest of the summer turning its round, mahogany hips into shiny black baubles. 'Madame Hardy', considered by many to be the purest of white roses, makes a good-sized, rounded shrub and the pretty, quartered flowers have the strong scent typical of Damasks.

These two roses, like the ramblers, bloom only once, but the effect that we are seeking is a combination of masses of white flowers and waves of perfume — requirements that continuously blooming roses are hard-pressed to meet. However, for those who insist on a longer season, 'Iceberg' still manages to surpass other and newer modern roses in beauty, bloom production and scent. It is not always a healthy rose, so be prepared to spray it if necessary. 'Margaret Merril' also meets the criteria of perfume and purity — although low-growing, it has a particularly enticing fragrance. A relative newcomer on the scene is the modern shrub 'Jacqueline Du Pré', with delicate white petals surrounding striking magenta stamens, and a sweet though not really strong scent. The jury is still out on its disease resistance: I threw mine out after blackspot defoliated it two years running, but others hail it as one of their healthiest roses. It is certainly worth taking a chance on.

Few white miniatures have any fragrance to speak of. If you are limited to little roses, the best bet for evening enjoyment is undoubtedly 'Gourmet Popcorn' with its sweet honey scent. Another option might be 'Cinderella', which is not quite white and only mildly scented, but it is delicate and pretty and in a small area perhaps the fragrance will appear stronger. 'Green Ice' has no fragrance to speak of, but massed in hanging baskets has the right visual effect.

Other Roses for Moonlight: Darlow's Enigma, Manning's Blush, Blanc Double de Coubert, Sir Thomas Lipton, Albéric Barbier.

Roses for Fall Foliage

Roses are not usually thought of as plants that can provide autumn colour in the garden, other than with a few late flowers, but there are several groups among the shrub roses with foliage that is well worth a second look as the year slips towards its end.

For the best colour in the fall we look first to the rugosa family of roses, whose tough, matte green, nubbly foliage (rugose = wrinkled) takes on autumn tints as bright as any tree or shrub. The majority of these big shrubs glow in a mixture of russet and amber as the weather turns colder, but a few really turn up the heat. 'Blanc Double de Coubert', with so much else already to offer, excels here too in the molten gold of its late leaves, accented by an occasional bright scarlet hip. Another standout is 'Thérèse Bugnet', whose leaves, smoother and more narrow than other rugosas, become suffused with dusky crimson and a touch of plum.

The dainty foliage of most of the pimpinellifolia roses, especially their species parent, becomes a deep purple backdrop to the shiny black hips. Species ramblers also provide a fall display. Rosa mulliganii, for instance, goes from shiny green to a shade like the red embers of a dying fire. Rosa virginiana, a North American native, is more inclined towards topaz flecked with garnet.

Other Roses for Fall Foliage: Fru Dagmar Hastrup, Rosa rugosa rubra, Rosa glauca.

Roses for Arches and Doorways

Any climbing rose will make an arch or doorway more attractive, but when you have a narrow passage where people are likely to brush against the sides of the opening, a second consideration comes into play. Nobody wants to be snagged on thorns as they arrive or leave the premises, so a rose that doesn't have the usual armour becomes an asset in these situations.

Probably the best-known thornless rose is the Bourbon climber 'Zephirine Drouhin'. With large, plum-coloured, heavily scented blooms that continue sporadically all season long, it sounds like just the ticket for a doorway. Unfortunately, it has a major drawback: the foliage is a martyr to black spot. At the height of its bloom it is a glorious sight, but all too often the foliage is an ugly disappointment. Choose it if you must, but cross your fingers! (I'm not a fan of spraying at any time, and even less so around heavily used areas, so I'm not going to condone dousing it with fungicides at regular intervals.)

Although 'Lykkefund' ('Lucky Find') will not bloom as long, and the individual flowers are small and simple, it will fill the air with the scent from its sprays of bloom in July and follow up with a fine display of orange hips later in the year. The smooth, wine-coloured canes are flexible when young and can be easily trained over any large structure, such as a portico. It is not a good choice for limited space or a modest arch, however. (This rose lives up to its name here in North America — you may find it hard to track down.)

Still considering large areas to cover, 'Veilchenblau' might suit your tastes if you have a penchant for unusual colours. This thornless rambler has sweet apple-scented flowers of plum, violet, lavender and grey shades highlighted on an occasional petal with a dash of white. It blooms heavily in July and has narrow, healthy, grass-green leaves which retain a fresh, polished look all throughout the season.

Less rampant, the snaking stems of 'Madame Plantier' can be painlessly threaded through a cross-hatched wire or wood support, and will cover it each June in clusters of lipstick pink buds and pure white flowers for a dazzling effect from top to bottom.

With these three roses, consider growing a late-blooming clematis through their canes to provide colour for the later months, but be sure to give both plants enough room for their roots — clematis roots can develop into quite a large, solid clump.

Among repeat-blooming roses, some of the taller Austin English roses such as the pale pink 'Heritage' or the golden 'Graham Thomas' are nicely suited to close quarters. Although listed as shrubs, both these roses will serve well to flank a small arbour, better perhaps than one of the more rampant growers. Neither has more than a few prickles on their sturdy canes. Another Austin introduction,'Leander', actually makes a better climber than a shrub and would adorn an arch very nicely with minimal support, although it does not reliably bloom more than once in a season.

The Floribunda rose 'City of London' will easily grow tall enough for an arch, is thorn-free, healthy, rarely without bloom, and very fragrant. If pale pink is your colour and you like sculptured flowers of good substance, this is the rose — better perhaps for this kind of use than in a garden bed.

Finally, all of the Miniature climbing roses are particularly well-suited to clothing a small arch of around 2.5 m (8 ft.), although none of them is thornless.

Other thorn-free roses for Arbours and Doorways: Lichtkonigen Lucia, Cardinal de Richelieu.

Roses as Security Devices

Not as silly as it sounds, this is the perfect job for any of the large thorny ramblers that can be trained to cover the length of a backyard fence. Just two roses will be sufficient for a property with a standard 50 foot lot width, while those with smaller lots may get away with one.

Rosa mulliganii, which has covered 40 ft. of fence after five years in my garden and is still growing, has the armour to deter any intruder, human or animal, who ventures too close. I'm not even game to approach it without some serious protection of my own.

The two sempervirens hybrids, 'Adelaide d'Orléans' and 'Félicité Perpétue' will extend horizontally to at least twenty feet each, have beautiful, fragrant flowers, almost evergreen foliage and vicious thorns. 'Félicité Perpétue', particularly, has a way of reaching out from its supporting cross rails to attack any unwary lane-lurker coming too close. Neither of these roses likes to be pruned, which is just as well, although you should take out some old canes at ground level each year to make room for new ones

'Albéric Barbier', which can sometimes be persuaded into a second cycle of bloom, although not nearly as prolific as its July explosion of soft yellow and cream, will also develop into a thicket of well-armed, whiplike canes which can be persuaded to envelop a large expanse of fence-line.

The free-standing alternative to ramblers is a row of thorny shrub roses, such as the thick, spreading 'Hansa', or the pretty, very prickly Austin rose called 'The Countryman' which is so hard to get near that at least one of my friends threw it out in a fit of revenge.

Even a few of the Hybrid Teas, such as 'Pristine' with its sturdy stems and huge thorns, can make a formidable barrier if planted along a boundary, although they don't fill in as thickly as shrub roses do.

One final suggestion: Rosa eglanteria is a rose of the hedgerows in England where it mingles happily with hawthorns and other shrubs to make an impenetrable barrier along the sides of country roads. For those with enough space who are

seeking an informal effect, this shrub grows tall and wide, has pretty but not spectacular pink flowers in summer, scarlet jewels of berries in winter, and, whenever in leaf, gives off the scent of green apples. And it has the nastiest sharp needles.

Other Roses for Security: (Ramblers) Albertine, American Pillar; (Shrubs) Sir Thomas Lipton, Rosa macrantha.

NOTES

Roses as Hedges

While they admittedly lack the year-round substance of evergreens for providing privacy at the borders of a domain, roses make excellent internal dividers for large gardens.

Rugosa roses planted about 1 metre (3 ft.) apart will soon grow large enough to make a solid barrier, and this particular group lend themselves to being cut and shaped to size. Of course, you can plant them farther apart and do no pruning if you want a higher, looser effect. I have seen 'Hansa' roses in the warm climate of Vancouver Island standing 3 metres (10 ft.) tall — a living wall of fragrant magenta pink. 'Schneezwerg' (Snow Dwarf), a compact white rugosa, would make a lower hedge — about 2 metres (6 ft.) high — while 'Snow Pavement' is lower still, reaching no more than 1 metre (3 ft.) but spreading to almost twice that in width.

Long used in Britain for informal hedging, the sprawling, thickly clustered canes of Rosa gallica offinalis, the Red Rose of Lancaster, make a tremendous sight when in bloom, and the variegated flowers of its close relative 'Rosa Mundi' are even more spectacular.

Many of the other members of the Gallica family are just as obliging as informal dividers, from 'Duchesse de Montebello' which is neat in shape, leafs out early with crisp green foliage and greets summer with a wealth of pale pink blooms, to 'Belle de Crécy', whose hot pink flowers fluctuate through lavender and grey as they age. Most of the Gallicas are almost thornless, which is an advantage if they are used within a garden space.

On the other hand, for a hedge along a boundary where a deterrent is needed, perhaps against roaming dogs, Rosa pimpinellifolia will put up a thicket of wiry brown stems, well-covered in fine, needle-like prickles. Grown on its own roots, this plant will spread gradually, becoming even more impenetrable as it increases in width. Its average height is around 1.5 m. (5 ft.). One of its descendants, 'Mrs. Colville', has sharper, more hooked thorns on its red stems and prettier foliage with steel blue overtones. The flower is cherry pink with a white centre, more vivid but not as scented as the parent.

Hybrid Teas and Floribundas are not good choices for this kind of treatment because they like more air circulation than tight planting allows. 'Iceberg' has been often recommended for this purpose, but I suspect that here it would need regular treatment against disease to perform well in this situation. However, some of the modern shrub roses are very tolerant of grouping in this way. 'Ballerina' is a very suitable subject for a decorative, low, informal hedge, and will flower for several months without a pause. 'The Fairy' is even better, having a slightly more upright growth habit and a green leaf that looks not unlike boxwood. Both respond well to clipping in the dormant season, and will not become too unshapely by season's end.

Where space is not a problem, 'Bonica' has great potential as a large, spreading hedge with its constant display of pink blooms and its orange hips to brighten winter days.

Other Roses for Hedges: Dart's Dash, Common Moss, Nuits de Young, Chinatown, Mountbatten.

Roses for Shade

This title is somewhat misleading, as roses are essentially sun-loving plants, but some of the hardy shrubs, climbers and species roses will tolerate a greater degree of shade, provided that they can either climb towards the sunlight, or get at least four hours of it in peak blooming time. Darkest red varieties will bloom more profusely in full sun, but their petals often blotch or fade in the intensity of midday light and heat. For this reason, it is worth settling for the fewer flowers of finer quality that a slightly more shaded location will bring. A prime example is the old climber 'Souvenir du Dr. Jamain', whose flowers only retain their deep blood-red colour out of the brightest light. This is not a healthy rose, whether in sun or not, needing attention to fertilizing and regular spraying, but its blooms are truly beautiful to see and to smell.

A better choice for a not so sunny spot is 'Madame Alfred Carrière', already recommended for other reasons. This strong, healthy climber will seek the light and produce most of its blush-white blooms in the sunshine, but it always has some to spare for the shaded branches. I grew it on the north wall of a house where the lower canes received almost no sun but still managed to put out some blooms; where it had reached into sunlight, it flowered generously.

For a lower-growing rose, 'Bonica' is a good choice; very generous with its pink flowers even in difficult situations, it has the bonus of colourful hips in winter.

The rugosa family, so adaptable to many awkward situations, is useful here too, and these varieties are particularly suitable for growing under evergreens or in poorer soil. Most of them will produce a reasonable number of flowers spread over a long period of summer and fall, as well as striking leaf colour towards the end of the year. Because they are so disease-free, they cope well with conditions that would challenge most other roses.

Many of the species roses like Rosa glauca grow in the wild in lightly treed areas, so the plants have a built-in tolerance for dappled shade at the very least. Rosa moyesii hybrids like 'Geranium' and 'Doncasterii' would settle in well, as would Rosa

pimpinellifolia and its offspring. The China rose 'Mutabilis' actually seems to perform better in some shade and will keep producing its curious, ever-changing little flowers well into fall.

Other Shade-tolerant Roses: Albéric Barbier, Felicité Perpétue, Fru Dagmar Hastrup, New Dawn.

NOTES

Roses That Can Take Neglect

Many gardeners, perhaps a majority, think of roses as demanding garden plants, requiring endless watering, fertilizing, spraying, pruning and general monitoring. This is largely because of the reputation established over the last century by the highly bred Hybrid Tea roses, which have offered bold colour, large flowers and, above all, continuity of bloom very much at the expense of durability and adaptability. If you are prepared to compromise on these features, and particularly if you are prepared to look at roses which, like most other shrubs — viburnums, rhododendrons, lilacs, weigelas, buddleias and hydrangeas, to name just a few — only flower for one month out of twelve, you will find that there are many undemanding varieties well worth the consideration of even the busiest gardener.

Here again, the rugosas shine. They do not suffer from the usual rose diseases, will put up with sandy soil, cold winters, wind, salt spray and shade and, in most cases, will produce flowers from late May till early October. These are fragile blooms, not individually long-lasting, and the colour range is limited to white and all shades of pink (with two exceptions: the yellow 'Agnes' and 'Topaz Jewel', which are not as trouble-free as the others). But the majority are sweet-smelling, have bright fall foliage and produce some of the best and biggest rosehips of all roses. 'Hansa', 'Roseraie de l'Hay', 'Schneezwerg', and 'Thérèse Bugnet" among others are as attractive as any shrub and sweeter-smelling than most.

Species roses like Rosa pimpinellifolia or Rosa glauca are also very hardy and easy-going in difficult circumstances, as are most of the old-fashioned Gallicas.

Big ramblers need to be well-watered while young, as they have a lot of growth to make but once-established can be completely ignored. In fact, they become so large and thorny that care is almost impossible anyway. Most of my ramblers grow on fences at the edge of my garden, well beyond the reach of a hose and compete for what nourishment the soil provides with a thicket of unmown pasture grass. Every summer, they demonstrate defiance of my neglect by producing wave upon wave of scented white blossom.

Other Roses that Can Take Neglect: Constance Spry, Common Moss, Flower Carpet, Green Ice, Nuits de Young, Rosa woodsii.

NOTES

Roses Native to the Pacific Northwest

Gardening with native plants is becoming a popular option for people who are concerned for the environment, and roses have a place here, too. There are reported to be as many as twenty-three different species of rose indigenous to the Pacific Northwest, although not many have found their way into commerce and the few that have are hard to find. Of them, Wood's Rose (Rosa woodsii) and Nootka Rose (Rosa nutkana) are the two most readily available. Both roses develop into thin-stemmed, upright shrubs with a height of about 150 cm. (5 ft.), and both have single, clear lilac-pink flowers, russet and old gold fall foliage and round red hips in winter. They are, like many wild roses, prone to spreading by suckers, expanding gradually into wiry thickets.

In the spring of 1999, the University of British Columbia Plant Introduction Scheme is launching a superior form of Wood's Rose, named 'Kimberley' for the area where it was discovered. 'Kimberley' blooms more profusely than other wild roses, has fragrant flowers, attractive blue-green foliage, bright red stems and hips and is recommended for naturalistic landscapes with good drainage. Travellers to the interior of British Columbia may have seen trial plantings on the slopes of highway routes through the Okanagan valley.

Other Native Roses: Rosa nitida, Rosa gymnocarpa

4 PLANTING YOUR ROSEBUSH

A few years ago, in a used bookstore in Halifax I found some verse on a scrap of paper being used as a bookmark:

The man that wants a garden fair or small or very big with flowers growing here and there must bend his back and dig. It matters not what goal you seek, Its secret here reposes; You've got to dig from week to week to get results or roses.

Not exactly upbeat, but all too realistic I think, as I survey my garden and look for more room for more roses.

It has been said by numerous authorities in numerous ways that the most important thing you do for any new addition to your garden is to plant it properly. Nothing else that you ever do for your rosebush will be as rewarding as the care you take in this first labour of love. Choosing the right location, preparing the ground and encouraging the roots to adapt to their new home are a form of insurance that will make all the difference to how well the rose will perform in the garden. Even the strongest, healthiest varieties may falter if the process of planting is not taken seriously.

Site Requirements

Sun. Roses will tolerate a wide variety of conditions in the garden. The most important consideration is that they have enough sun. This means choosing a spot that gets a minimum of six hours of sunshine a day. A few vigorous climbers and ramblers can do with less than this, but they will still climb towards the sun and flower best on the branches which reach it.

If you have the choice of morning or afternoon sun, opt for the former, especially if you are planting a dark coloured rose. The flowers of a rose such as the wine-red 'Souvenir du Dr. Jamain' have a tendency to fade in strong afternoon sunlight.

If you are determined to have a rose in a partly shady location, make sure it is one which will flower in less than ideal

circumstances, and be prepared to sacrifice constant bloom for one generous display in summer. It's not that once-blooming roses tolerate shade better, but that they bloom so heavily that even a reduced display gives a satisfactory result.

Soil.

Any reasonable garden soil will grow good roses, provided it is well-drained. Although roses are rated as heavy feeders, water is their most important requirement. However, this does not mean that they like to sit in it. Like most other plants, they will drown if the roots do not have an opportunity to breathe. In low-lying areas, it is essential to put in some drainage, and even more worthwhile to build up the garden beds by at least 20 cm. (8 in.) before beginning to plant.

It is useful to know the relative acidity of your soil. A simple pH test will give you a rating between 1 and 14; the lower the number, the more acid the soil, with 7 being the level at which the vast majority of plants are able to absorb the maximum amount of nutrients. Few plants survive outside the 4 to 9 range. Roses like to be just on the acidic side, around 6.5. Some rose societies such as the Vancouver Rose Society provide members with advice on collecting a soil sample as well as free pH testing, but there are soil laboratories in most large cities which will do the test for a modest fee.

That said, the majority of gardeners do not bother to test their soil, and provided you are enriching your garden beds with compost or fertilizer on a regular basis, your roses should be happy. It is, however, important to add dolomite lime to the garden, preferably during the fall so that it can sweeten the soil over the winter (unless you have been topdressing with mushroom manure which has the same effect.) The high rainfall of the coastal Northwest keeps our soil acidic, which is why conifers, rhododendrons and other acid-loving plants thrive here.

Do not plant your rose too close to an existing tree, where it has to compete with the tree roots for nutrients. In all but the most vigorous cases, the rose will lose. If you have a vigorous rose in mind because you want it to climb the tree, dig a large hole and remove all tree roots from the vicinity. They will grow

back, especially if you feed and water in that area, but as long as you choose a suitable variety, such as 'Bobbie James',or 'Rambling Rector' and give it a good start, it has a reasonable chance of fending off the competition. All the same, it is not a bad idea to bury some kind of barrier, such as a piece of aluminum flashing, between the tree and the rose to even out the competition a little.

Avoid planting a rose close against the house for two reasons: first, the roots will be deprived of the water they need by the roof overhang; second, salts leaching from concrete foundations, particularly if the house is new, can affect the growth of the plant. If you want to have a rose climb up the wall of your house, plant it on an angle 50 cm. (20 in.) out from the foundation and train it in toward the wall as it grows. It will eventually need that much space anyway.

When to Plant.

Provided that the soil is workable, and it usually is in the mild winters of this part of the continent, experienced rose growers like to mail-order bare-root roses and plant them in the fall. This gives the plants all winter to establish their roots with the result that they are ready to support vigorous new growth by spring. However, the vast majority of people still wait until the call of spring beckons them into nurseries to buy from the selection available there, much of it potted up just in time for opening day. The earlier the better is the watchword here, both because the selection is wider and because the roses have not had time to outgrow their pots or wither for lack of attention. Miniature roses and roses grown on their own roots can be planted without problems at virtually any time of year as long as they are already well-established in containers, and you are conscientious about watering them regularly.

Preparing for Planting.

If the area where you are planting the rose or roses is a newly made bed, double-dig the soil about three weeks beforehand so that the ground has time to settle before it is occupied. Double-digging means digging out the soil to a shovel's depth, turning over the soil below to the same depth

and then replacing the top layer again. Roses send their roots down quite deep, and this gives them a really good start. I emphasize that we are talking about the ideal here. You can grow perfectly good roses without this effort, but the guarantee of performance is not quite so assured.

If you are planting a number of roses, space them 60 cm. (24 in.) apart if they are modern hybrids, and at least twice that if they are Old Garden Roses or modern shrubs, unless you want them to eventually form a hedge.

Dig a hole approximately 50 cm. (20 in.) square and deep; mix the soil you remove with some well-rotted compost and, if your soil is heavy, some peat moss or alternative fibre that you have soaked well in water. If you like, add a handful of alfalfa pellets bought from a feed store, or dissolve a tablespoon of fish fertilizer in the water you are using. Do not on any account include fresh manure at this time - if it comes in contact with the roots, it will surely burn them. Avoid mushroom manure, too, which may contain harsh salts. Scatter a handful of bonemeal around in the hole unless you have moles in your garden. (Moles seem to be attracted to bonemeal and can leave your plant wilting in an air pocket after their investigations. Mix the bone meal through the top few inches of soil as you finish planting instead, and it will eventually seep down to the roots.) Fill the hole with water and do something else until the water has drained away.

Planting a Bare-root Rose

The most important point about planting a bare-root rose is to do so as soon as possible after you receive it. It will benefit from first soaking in water, well up to the top of the stems for 8 to 24 hours beforehand. (An empty garbage can makes a good container.) If you can't plant it in this time, perhaps because the ground is frozen, heel it in. This means digging a shallow trench in some unused part of the garden (the vegetable bed?) and laying the rose in at an oblique angle so that as you fill the trench with soil, you cover the roots and almost all of the stems, leaving just enough sticking out so that you can find it again. As soon as possible, dig it up and plant it properly. Roses can survive this treatment for several months, but it is better if you don't have to ask it of them.

When you are ready to plant, prepare the hole as above, and then put in some extra soil mix so that it forms a cone in the centre. Take your rose out from wherever you have been protecting it from drying out, and position it with its roots spread out as evenly as possible around the cone. Don't curl roots up if they are too long to fit comfortably into the hole; either enlarge the hole or clip long roots a little shorter so that new growth, when it occurs,will radiate outwards and downwards from the centre of the plant.

If your rose is a grafted one, hold it so that the bud union will be just below soil level when you finish filling the hole. It helps to place a stick across the hole to guide you with this manoeuvre. If the rose is growing on its own roots , you will have to judge the right depth for yourself - normally the level at which it is growing in the pot. It isn't critical, but err on the deep side if you are not sure.

Cover the roots with your soil mix, firming it down well and giving the plant a little shake to make sure you have filled any gaps. When the hole is two-thirds full, top it up with more water. After this has drained away fill in the hole with the rest of the soil and tread it down gently, working from the outside to the centre. If you have some additional soil mix, mound it up around the rose stems to protect them from drying out as the rose settles into its new position. If you have used up all your

mix, use a few scoops of soil from elsewhere in the garden. In a few weeks you can gently remove this extra soil. Washing it away with a hose will ensure that you don't snap off any new growth that has decided to sprout in the meantime.

NOTES

Planting a Container-grown Rose

If you are planting a rose that has been growing in a pot, and can do so without disturbing the soil around the roots, follow the instructions above, but mix a handful of slow-release fertilizer granules into the soil around the edge of the planting hole. This will encourage the roots of your plant to extend beyond the medium in which they are now growing. Place the plant, still in its pot, into the hole and fill the soil in firmly around it up to the rim. Then get a good grip on the rim and pull the pot out again. If you have packed the soil tightly enough, you will have a hole the exact size and shape of the pot. Loosen the plant in the pot, slide it carefully out with the soil intact, and drop it into the hole. It will never notice it has been moved! Even if the rose is in a pot advertised as biodegradable, do not trust this material to break down in the soil; at the very least, cut the bottom out of the pot before planting. I recommend that you remove it completely, giving the roots every encouragement to extend into the surrounding soil.

If, when you remove the pot, you notice that some roots have begun to spiral horizontally around the outside of the root ball, loosen them gently and shorten them as necessary or, in extreme cases, slash through them at two or three places around the outside of the soil mass with a sharp tool like an exacto knife to ensure that your plant doesn't strangle itself by continuing to encircle its own roots. Once the plant is in position, you can add a little extra soil, and mound it up if you like, but the less the roots have been disturbed, the less necessary this step becomes. This is the best, if not the only, way to plant a rose between late spring and the end of summer.

In the case of every new planting, it is more crucial than ever to water the roses regularly and deeply - at least once a week, more if the weather is dry. In their first year, fertilize them only after the petals begin to drop from the first flush of bloom.

Moving a Rose

Sometimes it is necessary to move a rose, either because *you* are moving and want to take it with you, or because it has grown too large for its present site. Or maybe, like so many gardeners, you are simply discontented with your existing design and feel like shifting everything around for a new look. Fortunately, roses move fairly easily, provided you take a few precautions.

The best time to carry out this operation is any day when the rose is dormant and the soil is workable. Late October or November is ideal because the roots will then have all winter to settle into their new plot before they are required to start supporting growth again. If this time is out of the question, the rest of the winter into early spring - before the plant leafs out - is the next best option. However, even if you have no choice but to make the move in high summer, the plant will still survive, although, of course, you will miss a year of bloom. Just make absolutely sure that the roots do not dry out and that you get it replanted as quickly as possible.

First, prepare the new location following the directions above for newly purchased roses, increasing the size of the planting hole if possible. Then, prune back the rose you are about to move to a manageable size. When you dig it out, try to get a good number of roots along with it. Don't worry if the soil falls away from them as you lever it out of the hole, or if you tear them with the shovel at this stage. Slosh some water over the roots and cover them with a tarp or a piece of wet sacking or even some layers of wet newspaper - anything to keep them moist. This is the most crucial element in the success of your venture.

Transport the plant to the new location, and trim the roots to fit the large hole you have prepared. You can now also trim any roots that are torn or broken, which will give the plant a better chance of regenerating growth from the cut ends. Plant the rose according to the instructions above for a bare-root rose, being particularly conscientious about watering it in well. If you have access to a willow tree, make some willow water by steeping a few twigs in a bucket for several days beforehand, and use this

solution instead of regular water. Willows contain a natural rooting hormone as well as salicylic acid (the ingredient in aspirin), making willow water a cheap and easy transplant medicine for any shrub, not just roses.

Conventional wisdom says to prune it hard now, and let it begin from scratch with new growth, but I must admit that I have moved a large rambler, hardly pruned it at all, and seen it flower the same summer as if it hadn't noticed. As this was a very vigorous plant, and I managed to keep a good chunk of the root ball intact, I would suggest that you do as I say and prune ruthlessly, rather than as I did in this particular case.

Hold back on the fertilizer, as you would for a new rose, until the plant is well established in its new home. And don't ask too much of it in the following season. It will need some time to recover from the move, but recover it will if it hasn't been allowed to dry out. Roses are tough.

5 CARE AND CULTIVATION

"It's a relief to find that roses don't mind moving although some take a while to adjust, especially if they are large. When I dug 'New Dawn' out, I left most of its roots under the house foundation, but three years later it's making good progress on a fence. I've tried the China rose 'Mutabilis' in three different places now and I think I've finally found a place it likes. 'Wedding Day', which grows huge for everyone else I know, has had two changes of location already and hasn't liked either of them. If I can think of another site for it, away it will go again, and I'll turn that spot over to 'Dr. Van Fleet', who may be more obliging."

Although some roses, notably the tough species varieties, will survive - and even thrive - with no maintenance at all once they are established, most roses do require ongoing care to give of their best year after year. Much of the following information is just good gardening practice whatever types of plants you are growing, but those who are new to gardening may find it helpful and even experienced gardeners may come across a few techniques that they haven't tried before. In particular, I have made a point of balancing traditional, more chemical-dependent practices with an organic approach so that gardeners have more than one option wherever possible.

First year

For the first year only after you have planted a new rose, do not fertilize it until after it has bloomed. Since you have already followed the planting instructions above, there are enough nutrients in the compost and bonemeal you added at that time to carry the rose through the spring. Giving a new rose the same dose of fertilizer as established plants is like giving steak to a baby - it is not mature enough to make use of it and may suffer as a result.

After the first blooms have faded, or by July if it has been growing well but has not bloomed, the plant can be given the

same treatment as other roses. (If it does not bloom at all in that year, which can happen especially with young own-root plants and once-blooming roses, leave it alone until mid-summer.)

Promoting Growth

Watering

Nothing is more important to roses than a regular supply of water. As one of my mentors is fond of saying, "Roses don't eat; they drink." Unless it has been raining steadily, or you have very retentive soil, give your roses a thorough watering at least once a week, more often in dry weather. If possible, use a system that keeps the water down low around the base of the rosebushes. Wetting the foliage creates conditions favoured by fungus diseases like blackspot and mildew. The best time to water is in the morning so that, even if the foliage does get wet, it will dry off as the day progresses. Watering early on a long summer evening is the next best time, again so that the foliage will dry off before nightfall. Avoid watering in late evening, as wet leaves overnight attract disease, or in the heat of the day when the intensity of the sun may burn the leaves, and some of the value will be lost by evaporation before the water reaches the roots. If you notice a rose wilting in the heat, by all means relieve its thirst but try to keep the water down around the root zone and make sure it soaks in well.

Fertilizing

Roses are heavy feeders. They like to grow in a rich soil, ideally with a clay base, but any ordinary garden soil will nourish good roses as long as you amend it regularly with compost or purchased fertilizers. Most nurseries sell a special rose food formula, usually something like *8-16-20* with trace elements. It is important for gardeners to understand what these numbers refer to and why they differ for different plants.

The first number is always the proportion, by weight, of nitrogen in the mix. Nitrogen is responsible for growth and particularly for the production of foliage. Add too much nitrogen to a plant and you will get lots of leaves at the expense of flowers.

The second number is the proportion of phosphorus. Phosphorus is the chief element of bonemeal, and encourages a healthy root system, which is why you add it to the soil at planting time.

The last number is always the proportion of potash or potassium. Potash encourages the production of flowers and fruit, and is also a factor in the hardening off of new shoots as they reach maturity.

Trace elements include magnesium, boron, iron, copper and manganese. Lack of these can stunt growth, and shows up most often in pale leaves or discoloured leaf veins.

This is oversimplifying the effects of each of these ingredients but at least it provides a rough guide to what you are doing when you amend your soil with purchased products, and why you should select one rather than another.

Many people dash into the garden centre and return with a container of *20-20-20* believing it to be the perfect all-purpose food for every conceivable type of plant. Indeed, it is an excellent product to use on container plants, including roses, but garden roses are best served by different balances of elements at different times of the year: more nitrogen in spring, more potash in late summer.

The first application of fertilizer that you make should be directly after you have done your spring pruning. In the Pacific Northwest that usually means around the end of February, beginning of March. Sprinkle a quarter of a cup of magnesium sulphate (Epsom salts) over the ground from the base of the rose out to the drip line, the point reached by the outermost leaves and branches. This will act as a spring tonic on your roses and get them off to a good start. You might want to omit this step if you put lime on the garden the previous fall, since lime also contains some magnesium, and it is better to underestimate the need for trace elements than add too much.

From this time on, the frequency with which you add fertilizer depends on the kind you are using. It is worth investing in a mix recommended for roses and an application of this according to the directions given on the package may be all you need. Because our soil tends to be deficient in nitrogen at this time of year, some rose gardeners like to use a lawn fertilizer,

such as a *12-4-8* mix with its higher nitrogen content than the type sold specifically for roses, for the first feeding in March, and follow up a month later with the 8-16-20 mentioned above. The latter comes in a slow-release form which means that one application should last the whole season, except on sandy soils which benefit from another dose after the first flush of bloom.

Nowadays there are some very good organic fertilizers on the market, which include fish meal, greensand, canola and kelp. Two applications a season, once after pruning and again, more sparingly, after the first bloom cycle, are usually enough.

How much is "an application"? The soil conditions in every garden are different, and here experience is your best guide. A handful per bush is an all-purpose way to begin if you are unsure, but since everyone you consult will likely have a different regime, you will determine what is best for you by observing the health of your plants carefully and experimenting over time. The same goes for how often to add fertilizer. Use the recommendations above only as a guideline, and if you visit a garden where the plants are doing better than yours, ask the owners about their soil and how often they amend it, and see if their system works for you. Easy on the food and heavy on the drink (watering, that is) is always a good axiom for the undecided.

Speaking of drink, water your garden before you spread fertilizer to avoid the risk of burning the fragile surface roots, and water again afterwards to dissolve the dry granules. Alternatively, put on your rain gear and do your fertilizing in the middle of a downpour.

Organic gardeners who have their own compost should aim to spread a good layer around each rose after pruning and supplement it again after first bloom. As with other fertilizer, water before and after spreading it. If the compost is manure-based, it has ideally had a year to rot before you use it, but you can use it even after a few months as long as it doesn't actually touch the growing parts of the rosebush. Chicken manure is particularly "hot" and should always be given a long period of decomposition before using.

Mushroom manure is an increasingly popular product and has the added advantage of being sterilised and therefore weed-free. Unfortunately, it is proving in the long term to be more

detrimental to roses than helpful, perhaps because of the high concentrations of salts it often contains.

Initially, rose gardeners, myself included, were enthusiastic about it, and indeed, early results were very promising. However, many of us noticed a slow deterioration with successive annual applications, and are much more wary of it now. When one colleague of mine dug up her bed of ailing miniature roses, removed the mushroom manure-based mix and replaced it with ordinary garden soil, she noticed a marked improvement in the growth of the re-established plants. If you want that nice, dark, weed-free look to your garden beds, I would suggest using mushroom manure no more than once every three years, spreading only a thin layer (no more than 5 cm. (2 in.), and alternating with fine bark mulch (not cedar!) in the other years.

Whatever fertilizing program you undertake, stop using any mix containing nitrogen after July. Otherwise your roses will continue to push out fresh growth which has little hope of maturing enough to survive the winter. Much better to let your plants conserve that energy for vigorous new shoots the following spring. What you can do after July is rely on foliar feeding. By this I mean mixing up a weak solution of liquid fertilizer and spraying your rosebushes with it. As with watering, choose early morning or evening to do this so that the liquid is absorbed into the leaves before the heat of the day or the chill of the night. Fish fertilizer is particularly good if you can stand the smell (it doesn't last long) and will encourage rich green, healthy leaves. Liquid kelp is another option. You can give your roses this tonic any time during the growing season, but it makes even more sense to treat your roses above ground after you have cut off the supply of fertilizer at root level. In early fall, many rose growers like to add a light sprinkling of sulphate of potash around their roses to help harden off young, sappy growth before the onset of colder weather. Potash is an element often lacking in our soil, especially at the end of the season.

Slow-acting dolomite lime can also be added to the garden in fall, so that it will be absorbed into the soil by spring. To be absolutely sure that your soil needs it, you should have a soil test done, but the high rainfall of the winter months in the

Pacific Northwest virtually guarantees a soil more acid than the optimum for rose-growing, so that adding lime is a reasonable course to follow in the absence of any scientific data about your personal plot of ground. Some people prefer to add a quick-acting lime in spring when they are routinely applying it to their lawns.

Mulching

Putting a layer of mulch over the surface of the soil helps keep water from evaporating and so contributes to well-fed roses. You can use almost any kind of organic material: bark chips, leaves (except walnut leaves which contain toxins), well-rotted manure, compost and old grass clippings are popular. Fertilize and water the soil before spreading the mulch in a 2.5 to 5 cm. (1 to 2 in.) layer. In the case of grass, be sure that it is not contaminated with weed killer from the use of lawn treatments such as weed-and-feed products. Allow three cuttings of a lawn before before you can safely use the clippings in the garden again.

While mulches can do a lot to keep the soil moist and control weeds, as well as having aesthetic benefits, be aware that anything not well-rotted demands nitrogen during the process of breaking down, and add extra fish fertilizer or some other nitrogen-rich material to compensate for this depletion.

Winter Protection

In coastal regions of the Pacific Northwest, the winters are usually mild enough that winter protection for roses is not necessary. However, tender roses will have a better chance of survival if some soil is mounded up around the base before the onset of icy weather. Take this soil from another part of the garden, perhaps the vegetable plot, rather than from around the rosebush itself where you run the risk of exposing feeder roots that lie just below the surface. When you remove the extra soil in spring it can go back to where you got it from if necessary. A good way to keep the soil in place around the rose is to make a collar of several sheets of newspaper doubled over and stapled together.

Standard (tree) roses can be protected by packing straw around the bud union and securing this with a wrap of burlap or fine wire mesh. (It doesn't look pretty, but this type of rose is expensive to replace.)

Most roses, even if killed back above ground by severe weather, will rebound in spring provided that their roots and the graft union have been protected from freezing. In our climate, a greater danger comes from the desiccation caused by cold winds. Climbers are particularly affected by this. If they are in an exposed area, you can provide some protection by wrapping them in a breathable material like burlap, although it is often difficult to disentangle this from the thorns later on. Climbers against a house can be protected by stapling several layers of newspaper over them. This is not a particularly attractive solution, and, in one instance I know of, drew a visit from a siding-repair salesman.

Winds can also whip and damage, or even snap, long canes on on any rosebush. It is a good precaution to secure or shorten the stems on any potential victims when you do your fall clean-up of the garden. Along with mounding up the soil, this bit of judicious pruning will also help prevent "wind-rock". Strong gusts can loosen a plant's grip on the soil; as it rocks under the pressure, tiny surface roots break and the plant becomes increasingly unsteady, scouring a hole around its base and providing a gap for moisture to fill and turn to ice with obvious dire results.

Controlling Growth

Once your roses are established and growing well, they will eventually require some intervention by you to keep them at their best. The most important control you exercise over them will be pruning. In fact, this is such an important part of the maintenance program (and causes so much unnecessary apprehension) that it deserves a chapter of its own - which follows.

Apart from pruning, there are some other techniques which you can use to achieve certain results. These include:

Finger Pruning

Each growth point on the stem of a rose is capable of generating three shoots. Often all three begin to grow at the same time; ignoring them means that each will develop and you will end up with three thin twigs. Sometimes one or two will die

off naturally, leaving the strongest to continue, but to ensure a single sturdy stem, you can carefully rub off the two weakest shoots with your thumb when they are all still very young. If this new growth is emerging near the base of the plant and is pointing towards the centre of the bush, it is a good idea to rub off all three shoots to maintain a pleasing shape.

Disbudding

This involves using the same technique as finger pruning but on the flower buds, and is usually only practised on Hybrid Tea roses to encourage one large bloom rather than three small ones. Many of these roses have been bred to produce one flower per stem, but sometimes three buds will emerge, with the largest in the centre. If left alone, the middle bud will mature before the other two and die earlier. This doesn't really matter in a plant grown for garden enjoyment, but is of great concern to exhibitors in rose shows, where a standard of one bloom per stem prevails for Hybrid Tea classes. If you are growing your roses primarily for cutting, you might want to take advantage of the disbudding technique to achieve that long-stemmed florists' rose effect. Snap or cut off the side buds when they are tiny to avoid leaving visible scars or, worse, inadvertently deleting the middle bloom as well!

Deadheading

With the exception of once-blooming roses, such as the species and many Old Garden Roses, cutting the spent flowers off a rosebush will encourage the next flush of bloom, and the new growth will be more vigorous since the plant is not continuing to support the stem holding the dying flower. It looks a lot tidier in the garden, too. When you deadhead, cut back to the first strong set of five leaflets below the spent flowerhead. You can follow the same practice with once-blooming roses, simply for neatness sake, or do a more thorough pruning to shape them for next year. However, many of the once-blooming roses follow their flowers with a display of colourful hips which are attractive through the winter months as well as providing food for birds, so you may want to tolerate a brief period of untidiness to enjoy these later benefits. These roses thrive

without any pruning at all, and can always be trimmed a little in spring if absolutely necessary. "A little" is the operative phrase, though, as you will be reducing the number of flowers with every cut.

Regardless of the type of rose, stop deadheading in October to let the plant follow its natural inclination to go dormant.

Eliminating Suckers

Grafted roses, which includes almost all roses sold commercially unless they are specified as own-root, usually grow quite happily on their borrowed roots without any problems. Occasionally, however, something causes the root system to send up one of its own shoots, rather than directing its energy into the variety grafted on top. This shoot, or sucker, is usually easy to identify: the leaves are different -often smaller and lighter in colour with more leaflets to each leaf than the usual five; the stem is thinner and often more prickly and emerges from the ground below or away from the bud union or crown and, if it blooms, the flower is different in both size and colour from the rose you expected.

Suckers must be eliminated or they will gradually take over the plant, monopolizing the energy from the roots until the rose that you originally bought no longer exists. Cutting them off at ground level only encourages a forest of more stems. They must be traced back to the point at which they emerge from a root and ripped away if possible. If the stem is quite tough by the time you have noticed it, then cut it as close to the root as you possibly can.

Eliminating Growth.

Dieback

Although you normally remove dead and damaged growth from a rosebush at pruning time, it is not uncommon for the tips of the pruned canes to be killed back even further by a late bout of severe weather. The dead area is usually easy to see, being either blackened or shrivelled and dull. If this happens, cut back to healthy growth again, ideally to another outward facing eye.

If you are down to the last remaining eye, as sometimes happens, and it isn't facing out, you have the choice of leaving it anyway or cutting right to the crown and hoping for new growth from there.

Blind Shoots

Some roses, particularly the Rugosa family, have a tendency to put out blind shoots. In other words, the end of the cane, instead of producing a flower bud, will produce merely a tuft of green leaves. When this happens, the only recourse is to cut back to a strong leaf and hope that the resulting new growth will produce a flower. Check that the tiniest leaf tips are green, not black. The latter case may signal the attentions of rose midge (see Chapter 7 on Pest Control.)

6 PRUNING

One of the most encouraging things I have learned about roses - and I've learned it the hard way - is that they seldom die from pruning mistakes. They may grow thin and spindly, they may look terribly misshapen, they may refuse to flower, but they're awfully hard to kill this way.

Spring is the season when many otherwise-confident gardeners experience anxiety attacks. It's called Fear of Pruning. For some reason roses are high on the list of plants which arouse this fear, even though they are generally tough enough to withstand any amount of rough treatment with the clippers. A well-known experiment conducted at St. Albans, the headquarters of the Royal National Rose Society in England, found that Hybrid Tea and Floribunda roses trimmed with hedge clippers showed little difference in performance from roses trimmed by hand in the traditional way. While this sounds reassuring, the hedge-clipper method does not remove old or dead growth, or unproductive twiggy growth, so that, over a longer period of time than one summer, the rough-pruned roses would eventually suffer somewhat. Suffice it to say that no pruning is worse for these types of roses than any amount of overpruning could be. On the other hand Old Garden Roses and ramblers are often at their best left unpruned as part of their attraction lies in their gracefully arching habit.

The important thing to remember about pruning is that you don't kill a rose by doing it. A plant may die for any number of reasons - soil or weather conditions, a poor variety for our climate, a weak plant from birth - but pruning isn't one of them. And rosebushes are also very forgiving: if your pruning was less than successful this year, you can try all over again next year.

Modern Roses

The following pruning method applies to Hybrid Teas and Floribundas, and can also be used on miniature and small shrub roses as well as the smaller David Austin varieties.

First of all, when should you begin pruning? For our climate and conditions, late February through the first half of March is about right, but every year has its idiosyncrasies, so the most foolproof rule is to begin pruning when the Forsythia blooms. This doesn't sound very scientific, but a good number of rose gardeners, including me, find that it works just fine. Even if you don't have a Forsythia yourself, one of your neighbours is sure to have it. It's the shrub with cascades of small, golden yellow flowers which blooms brightly in many gardens as spring approaches. It will flower earlier close to the coast than it will inland, so wait until you see it blooming in your neighbourhood.

Gather your tools. You will need a good pair of bypass pruners (the anvil type tend to crush the stems unless they are really sharp), a pair of loppers for heavier canes and a keyhole pruning saw for very old or dead canes. Most important of all, be sure to protect your hands with a sturdy pair of thorn-proof garden gloves. There are horror stories in every rose society about infections caused by thorns penetrating a vein. My favourite gloves are made of strong cotton dipped in a rubber-like nitrile coating, which is both waterproof and impact-resistant.

Begin by studying the rosebush carefully, paying particular attention to the area just above the bud union, the point from which the canes emerge. Your purpose is to separate in your mind's eye the young, strong canes, which are smooth and green or pinkish-red, from the old canes which are dark brown to grey and often have a rough texture. If you have a good number of younger canes, use loppers or a pruning saw to remove any old canes as flush as possible with the base. If most of the growth is old, be ruthless and take it all out to encourage the maximum new growth. Can't bear to be that brutal? Okay, then at least remove half the old canes this year, and with luck you'll get enough new growth to encourage you to do the rest next spring.

Next, remove any younger canes that cross back through the centre of the bush either completely or back to the main stem from which they came. Always make your cut with the blade of the pruners closer to the base of the rose and the claw towards the outside so that the pressure you exert acts on the part of the cane that you are cutting off. Where two canes crowd each other, remove the weaker one, or the one growing at a less desirable angle.

Ideally, this will leave you with four or more young sturdy canes radiating symmetrically from the base. In practice, however, the ideal rarely occurs. Sometimes a rosebush has only three or four canes to begin with, in which case it is better to leave them all provided that they are still capable of producing new growth. If, on the other hand, your plant has more than four canes, you have some flexibility about which ones to remove to achieve the most pleasing shape. It is tempting to leave all the canes if they are strong and healthy, but reducing them to no more than five will encourage the plant to generate new growth for succeeding years.

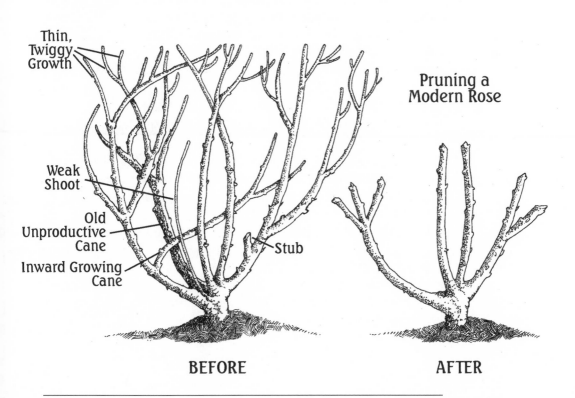

Thin, Twiggy Growth

Pruning a Modern Rose

Weak Shoot

Old Unproductive Cane

Inward Growing Cane

Stub

BEFORE

AFTER

Finally, cut out all thin, twiggy growth less than the diameter of a pencil and cut back to a still-dormant bud all the stems that have leafed out already. This should reduce the height of the bush to at least half the original size in the case of Hybrid Teas. If you want fewer but larger flowers, cut lower still, leaving as little as 10 cm. (6 in.). Floribundas can be left a little taller. The important thing is always to cut just above a dormant eye that faces away from the centre of the bush. Why? Because the top bud on any branch will grow more vigorously than any below it, and you want that growth to be curving out like umbrella spokes all around your rosebush, not pointing in towards the centre. Slope the pruning cut down and away from the bud at a slight angle. To prevent cane borers from tunneling into the exposed pith, dab all pruning cuts on thick canes with carpenter's glue. The borers rarely do much damage but they can cause enough dieback that your topmost bud is killed, and the one below is almost always facing in the wrong direction.

New roses and weak plants need harder pruning than established ones. Cutting all the canes down to about 10 cm. (6 in.) or even less - i.e. leaving only two or three bud eyes on each stem- may seem brutal but there are good reasons for doing so.The most important one is to encourage all the new growth to come from close to the base, giving the rose a good framework to build on in later years. Another is to balance growth above ground with growth below. Nurseries often cut the roots quite short to fit the plant into its pot; until the roots have had an opportunity to recover, they can't be expected to support much top growth.

In most years, once your pruning is completed, you can relax and look forward to summer blooms. Occasionally a late spring frost will cause some additional damage to the ends of the canes, which will turn black. If this happens, get out the pruners and recut until the pith at the centre of the each cane is the colour of a freshly cut apple. Be ruthless; if the pith is brown and pulpy, that part of the cane is dead anyway, even if it appears to be leafing out. If you have to cut all the way to the bud union, console yourself with the thought of new shoots, now invisible, seizing this chance to emerge.

Old Garden Roses

The majority of OGRs (Old Garden Roses) a.k.a. antique roses, bloom only once a year, in June-July, and require a very different treatment from modern repeat-blooming varieties. It is summed up in a few simple words: when in doubt, don't! Hold off especially when they are young plants so that they have an opportunity to develop a natural shape. Allow them at least three years free from the threat of pruning after which you can remove dead and unproductive canes, and trim back any growth that extends beyond an appealing outline. While dead wood can be removed at any time of year, do any shaping as soon as the petals drop. These roses bloom on growth formed in the previous year, so each snip you make in spring is going to deprive you of some of this year's flowers.

This kind of rose often begins life by producing spindly canes that sag under the weight of flowers and there is a terrible tendency for gardeners who have been used to growing modern roses to cut these back severely under the illusion that this will encourage stronger stems. Sadly, this merely results in twice as many thin, wispy growths, with the result that the gardener declares the rose unworthy, and a viburnum or other obedient shrub soon takes its place.

Left alone, the spindly stems will gradually increase in girth, just as a tree does, and will eventually provide a strong framework supporting many flowering offshoots. Unlike a tree, though, each cane has a productive life of only a few years, after which it should be pruned out completely to make way for new growth. In some instances, such as a large, free-standing bush, it's worth leaving the old canes to form an underpinning for new growth. Once the bush has leafed out, this basketwork of dead sticks is invisible.

A few types of OGRs have a second season of bloom in early fall, notably the Bourbons, Portlands, and Hybrid Perpetuals. These varieties should be lightly pruned in spring at the same time as modern roses. Take out at the base any weak, spindly stems and thin where necessary. Once every three or four years prune more severely to renew growth.

If you have the space, you can experiment with "pegging

down", another method of controlling those Old Garden Roses that produce long, whippy canes. Instead of trimming them back after they flower, you bend down the long canes and pin the tips to a peg of some kind driven into the ground. The result looks a little odd in winter - like an umbrella frame or a large spider - but new shoots springing all along the length will give you far more flowers the following summer than an upright bush will produce.

NOTES

Climbers and Ramblers

Climbing roses should not be pruned like bush roses. These plants produce their flowers on laterals, the short stems coming from the long main canes, so you want these main canes to grow long, and at the same time you want to encourage as many laterals as possible. This is done by bending each main cane down towards the horizontal, which will cause new laterals to break out from dormant buds along its length. If your rose is climbing up a pillar or a pergola support, try to wind the young flexible canes around the support, or train them from side to side in an ascending arcs, in order to ensure the growth of laterals down around the base. Only let the rose climb straight up if you want all your flowers overhead.

In spring all laterals should be cut back to leave two or three sets of leaves. Cut so that the top bud faces in the direction you want the new growth to take. Some people do not like the stubby look this creates, and they cut the laterals off completely, flush with the main stem, to force an entirely new lateral from that point.

Often the tips of the main canes are killed by frost, or have reached the point where you want them to stop. In either case,

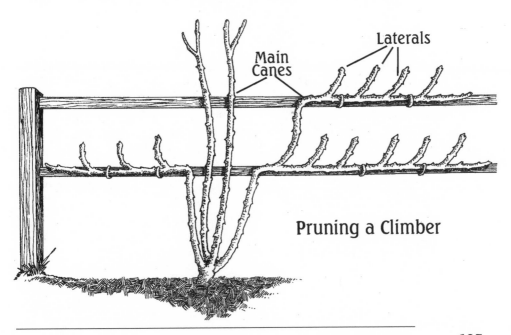

Laterals

Main
Canes

Pruning a Climber

prune the tip back to just short of a strong growing lateral. This will then become an extension of the original main cane.

A rambler should be treated like other once-blooming roses and allowed to grow without pruning. If growing on a fence, it should be trained horizontally like any climber, but don't trim the laterals as you would with a climber; try as much as possible to weave them into the horizontal framework. Most ramblers have vicious thorns, so don a suit of armour and take out an insurance policy before attempting this manoeuvre. If you do want to exercise some control over a rampant grower that is getting out of bounds, this is one instance where hedge clippers are in order - much easier on you, and the rose will hardly notice.

If the rambler is climbing a tree, no pruning is possible anyway. Be patient. In its early years, the plant will use most of its energy for climbing rather than blooming, and you may have to wait up to four years before it puts out enough laterals for a really spectacular array of bloom. Mature climbers and ramblers should have some of the older, less productive canes removed at the base every year to encourage some new young canes to grow.

Shrub Roses

Shrub roses, a category which includes the David Austin English roses, are tolerant of a wide range of pruning techniques. On smaller bushes, pruning them as you would a Floribunda rose, leaving only the strongest canes, generally gives good results. Treat more vigorous varieties like Old Garden Roses and allow them to develop as they choose before any pruning is done. This is particularly true of the larger David Austins whose naturally arching habit should be encouraged. In this group, the most important factor is to select a rose whose mature size is suitable for the site you have in mind and be prepared for it to lean gracefully over whatever is in front of it. If you have to trim it too harshly "to fit", you won't then be satisfied with the resulting shape.

Miniature Roses

These little specimens are trimmed much the same as their big cousins, but of course, on an appropriate scale. One well-known miniature specialist likes to give his plants an all-over haircut with hedge clippers, and then tidy up with his pruners, taking out the dead wood and inward growing twigs with more care. It works very well. Since most miniature roses are "own-root", a good pruning will generate many new fresh shoots from ground level.

NOTES

7 PEST CONTROL:
Escalating Levels of Warfare

We live in an area dominated by horse people; in fact, we're probably the only people on our road who don't own horses. One day when I was down by the fence that runs along the road, trying to jam a rambler into a space between the wild currants and hardhack, two riders came by. "You know," said one of them, oblivious of my presence among the bushes, "That could be a really nice field. First, I'd get rid of all those shrubs...

"Over my dead body!" I said, rising inelegantly out of the foliage. I think she was a bit surprised."

Mention roses and, although most people immediately think of the contribution they make to the garden in terms of flowers and fragrance, there's always someone around who has given up on them because they are "too difficult to keep healthy". While there's no denying that they are as attractive to some insects and diseases as they are to us, protecting them against these perils doesn't have to involve non-stop warfare.

The first step is to choose a healthy variety. Those recommended in this book have all proven their worth in our climate, and cover as wide a range of sizes, shapes, colours and growth habits as possible. Nevertheless, this does not mean that every specimen will thrive in every garden. If a plant has not been well cared for before you buy it - has been allowed to dry out in the nursery, for example- it may never fully recover its vigour. And every garden has its own micro-climate which may require a rose with an iron constitution. Sometimes, a particular plant is simply a poor example of its variety for unaccountable reasons.

In other words, even a carefully selected rose may turn out to be a dud in your garden.

If that's the case, I suggest you throw it out and start again, either with another plant of the same variety, or with a totally different one. There are thousands of beautiful roses available today, just as lovely as the sickly one you are striving to nurture. Don't let it break your heart, or worse, turn you off roses altogether.

If you truly cannot be that ruthless, perhaps because the plant in question has sentimental value or was a gift from your wealthy old uncle, some of the following measures may help.

The most important thing you can do to keep your roses healthy is to plant them carefully and keep them well fed. Take the time and trouble to follow the procedure for planting outlined elsewhere in this book. Follow with regular fertilizing every year and water deeply once a week, particularly in a dry summer. Do the appropriate pruning and clean up spent petals and leaves, especially in the fall. Insects and disease spores overwinter in the litter of dead material under the bushes.

With these precautions you are giving your roses every opportunity to resist invasive forces. Beyond spraying with a lime sulphur/dormant oil mixture, or in alternate years a copper sulphate/dormant oil mix, before new growth occurs in spring, I resist taking other preventive measures, partly from scepticism about their effectiveness, partly from laziness. If a problem then arises, I deal with it at that time. If you are blessed with greater perseverance, and are willing to grow roses that suffer markedly from diseases such as black spot, you should also be willing to use chemical controls.

Although I prefer to garden organically, I am not against the judicious use of commercial products, as long as they are of low toxicity, indicated by a "caution" warning on the label.(Most fungicides, for example, are no more toxic than table salt.) I do not, however, believe that the use of pesticides carrying a "danger" or "poison" label is justified for any of the problems suffered by roses. By the same token, I find equally unacceptable the use of "organic" solutions such as the liquid derived from soaking cigarette butts in water, or a potion concocted of rhubarb leaves, either of which can result in a highly toxic brew more dangerous than any product permitted on the commercial market.

If you resort to spraying, regardless of what I or anyone else says about the harmlessness of the product you choose, cover up, protect your eyes and wear a mask for your nose and mouth. These precautions are cheap and easy to take, even though the sight of you may terrify your neighbours. Remember that DDT was once considered harmless too.

Diseases

Black Spot

Of all the diseases that can threaten a rose, black spot is undeniably the worst, both in its virulence and its appearance. Leaves show round, black blobs, which multiply at a rapid rate. Eventually the leaf turns yellow and falls off. The disease usually begins at the bottom of a plant and works it way upward. Black spot spores thrive in the moist, humid conditions that our weather tends to provide all too often. These spores will overwinter in fallen leaves as well as in the leaf axils (where the leaf joins the stem) and even under the "skin" of the rose, so meticulous clean-up is part of any preventive program. Watering in the morning so that surface moisture dries off promptly also helps.

Although present in early European rose gardens, the disease was a minor problem until *Rosa foetida*, a Persian species, brought the colour yellow to the hybridizer's palette in the nineteenth century. From the offspring of this rose have come the vibrant modern colours that are so popular with many gardeners - vermilion, orange, gold and apricot. Unfortunately *R. foetida* was also riddled with black spot and has passed its susceptibility along in tandem with the new, bold colours. Some rose growers believe that yellow roses are, even after generations of dilution, still more likely to attract black spot than roses of other hues.

The traditional treatment for black spot is a preventive spraying with a suitable fungicide (brand names Funginex and Benomyl, for instance) every two weeks during the growing season, alternating products so that the disease does not develop an immunity. However, even in rose gardens where this regime has been scrupulously followed, the disease has only been controlled rather than eradicated. Although these fungicides are very low in toxicity, another ingredient in the solution has been known to cause eye irritation, so be sure to wear protective glasses or a mask when spraying. Recent experiments with a solution of baking soda - 1 level tablespoon

to 4 litres/1 U.S. gallon, plus a tablespoon of horticultural oil to make it stick to the leaves - has shown some positive effects, but so far nothing really conclusive. This is a recourse to consider only after you have noticed signs of disease, not before. Apparently, it works by altering the pH balance on the leaf surface to one inhospitable to the black spot spores. Last year came news from England that the Danish Rose Society was reporting good results with a mix of equal parts skim milk and water! If only a few lower leaves are affected, you can simply pick them off and dispose of them in the garbage or burn them. In any case, you should tidy up fallen leaves around affected plants and strip them of all foliage at the end of the season to eliminate as many of the spores as you can from the surrounding area.

Because black spot is one of the hardest diseases to eradicate once it gets a hold, this is where I most recommend hardening your heart and "shovel-pruning" the rose if it continues to suffer badly. By all means, follow the hygiene procedures above and give it a year's grace, but two bad seasons in a row are a pretty good indication that it's not going to improve.

Powdery Mildew

Powdery mildew is another very common disease of roses, especially towards the end of the season, when it also affects other species such as phlox and some vegetable crops. Lack of air circulation invites an attack of mildew, which explains why it is often most prevalent on roses planted against a wall.

The fungicides used for black spot are also recommended for deterring powdery mildew. A dusting of sulphur powder is also beneficial. Organic gardeners can apply baking soda dissolved in water as described above for black spot - in fact, preliminary results have shown this to be more effective on mildew than on black spot. If only the tips of new growth are affected, I recommend simply cutting these off, as you would be doing in spring anyway during the usual pruning.

The bad news about powdery mildew is that susceptible roses will predictably suffer from it every season; the good news

is that, if these are vigorous varieties, like the climber 'New Dawn' for instance, it will not noticeably affect their health.

Downy Mildew

This is a relative newcomer to the Pacific Northwest, and is unfortunately not easy to control. In spite of its name, it looks much more like black spot than powdery mildew, and can easily be mistaken for it. Unlike black spot, however, downy mildew usually begins at the top of the plant. Dark purple spots or irregular blotches like bruises appear on young leaves and spread to stems, sepals and even petals. If you turn a leaf over, you can sometimes see the dusty, greyish look more usually associated with mildew. An early warning sign is often a slight crinkling or distortion of young leaves. Ideal conditions for downy mildew are several days of rain followed by a warm spell, then by more rain - typical West Coast weather, in other words.

This fungus has been more common in the past on vegetable crops and this is the section of the garden centre where the majority of products to control it can be found. The active ingredients are usually zinc or manganese. Copper sprays also attack the disease. Although best applied in the dormant season, they can be used in the growing season, but at a reduced intensity. The instructions with the package will tell you the proportion appropriate to the season.

In our climate, it is faint consolation that downy mildew cannot survive a temperature of more than 26 C (80 F) for more than 24 hours, but if all else fails, you can always pray for a heatwave!

Rust

Rust is a virulent disease but is fortunately not a major problem in our region. It appears as tiny, prominent, fuzzy-looking orange spots on the leaves, often on the undersides, which gradually increase in size and darken to brown and eventually black. You may have seen it on hollyhocks, which it

seems to have a passion for. In my experience, the hollyhock strain of rust does not transfer itself to roses although the look of the beast is the same. Control of rust is difficult: a copper, zinc or manganese spray - as for downy mildew - may help, but this is another case where I feel it is better to ditch the affected plant. By all means, try another plant of the same variety, but don't plant it in the same spot. That would be asking too much!

Crown Gall

This is a disease almost always associated with grafted roses, which are infected by the use of contaminated wood or tools at the time the graft is made. It appears at the base of the rose as a rough, warty lump with a spongy texture that gives slightly under pressure from your fingers. Ignored, it will eventually sap the strength of the rose to the point of killing it. Control is difficult: cut out as much of the affected area as you can, back to hard, clean wood, and sluice the wound with a 20% bleach, alcohol or Lysol solution. Dip your tools in the solution when you have finished, to avoid transferring the disease to other roses. (Lysol will not rust the blades of your tools the way bleach does.) If this drastic measure fails and the gall reappears, you have no recourse but to shovel-prune the plant. It's wise to let a few years go by before putting another rose in its place.

Occasionally, a gall may appear further up the canes where a wound has occurred, perhaps from pruning with clippers infected by another rose. In this case it is easier to cut off, but monitor that plant for signs of its reappearance. In very rare cases, galls may occur on the roots of a rose, even one grown from a cutting if the infection was transferred by infected pruners at the time of propagation. The only way to discover if this is why a plant is ailing is to dig it up, which you will eventually do anyway if it continues to suffer ill-health in spite of all your ministrations.

Crown gall rarely seems to infect nearby roses in the garden unless transferred physically from one to another, but be vigilant just in case.

Spot Anthracnose

Not a widespread problem on roses, spot anthracnose seems to be more partial to Old Garden Roses than to modern hybrids. Affected foliage shows small, round, dark spots, silvery at the centre, making the leaves look as though someone has burnt them with a cigarette.

The simplest, but most time-consuming solution, is to strip off infected leaves and dispose of them. Resulting new growth is rarely affected. In the dormant season, apply a copper or lime-sulphur spray which should provide protection.

Mosaic Virus

Here is one disease that was not caused by factors in your garden. The roots were already infected at the time the plant was grafted, long before you bought it; the symptoms merely take a year or two to show. The problem is also far more widespread in the United States, where the practice has been to develop rootstocks from cuttings, than in Canada where most rootstocks are grown from seed (which does not transfer the virus), so buying from a Canadian source is one precaution against it.

An affected rose will have a yellow patterning on its leaves, almost like the foliage of variegated shrubs such as Aucuba. There is no cure, except removing the plant, but the good news is that other roses in the garden are not at risk. Often the symptoms disappear by midsummer, only to reappear with next year's spring growth.

Environmental Factors

Occasionally roses exhibit signs that look as if they might be indications of disease but are, in fact, caused by weather or soil conditions or, very occasionally, are characteristic of a particular variety. For example, spots of water on the foliage on a hot day may produce a fine shot-hole effect on the leaves

caused by rapid evaporation and subsequent burning where each tiny droplet landed. Heavy dew can cause speckling, especially on the young leaves of varieties with shiny foliage. A few rambler roses, notably those related to Rosa sempervirens, such as 'Adelaide d'Orléans' and 'Félicité Perpétue', demonstrate their dislike of any spray by breaking out in spots. Many rugosa roses also react badly to sprays. The shrub rose 'Stanwell Perpetual' develops a natural purple mottling on mature leaves that can look very much like disease.

Petals of particular colours are more likely to react to weather conditions. Deep red roses have a tendency to fade and burn in hot sun, and, at worst, the edges of petals curl, dry up and turn brown. White and cream roses often exhibit green or pink spots or streaks on the outer petals.

The canes of some varieties, such as the shrub rose 'Sally Holmes', tend to develop reddish blotches which are part of their genetic inheritance. It's not always easy to distinguish these characteristics from disease, but try to eliminate them as possibilities before you reach for the arsenal. Soil deficiencies tend to show up in the leaves. Pale leaves may signal a nitrogen shortage, brittle brown edges a lack of potash (or a late frost). Yellowing of the veins is often caused by waterlogging, and if the veins remain green while the remainder of the leaf is yellow, the soil may be deficient in iron.

Predators

Aphids

Although aphids are the most common and one of the most visible pests of roses, they are among the least threatening to the health of the plant. Most aphids look like small, light green seeds moving in clusters over a shoot or bud; occasionally they are white, grey, brown or black, or have wings.

The simplest, safest method of control is just to knock the little beasts off with a strong jet of water from a garden hose. The most satisfying is to squish them by gently running your fingers up the infested shoots (don a pair of gloves if you're squeamish). Nine times out of ten, this is all that is necessary, especially if you have ladybugs in the vicinity. One ladybug can demolish a horde of aphids in a day, and it seems that in recent years there have been increasing numbers of these beneficial little creatures in our geographic area. At least, give them a chance by delaying any more drastic measures for a few weeks after you first notice the aphids.

If all else fails, really persistent infestations can be controlled by spraying with insecticidal soap. You can make your own concoction of soapy water, preferably from liquid pure soap, but be careful not to make it too strong or you'll burn the young growth, which is worse than the damage inflicted by the aphids. A teaspoon in a litre (quart) of water is a safe amount. Be aware, too, that you may be killing some of the insects that prey on the aphids.

As a final preventive measure, check the plant stems and the soil around the rose for evidence of ant colonies, and if you find any, get rid of them. The ants are working against you by cultivating aphids in order to milk them of the honeydew they exude.

Spider mites

Hot, dry weather introduces the ideal conditions for spider mites to appear. Infected leaves, usually at the base of a plant,

look dull and parched to the point of turning bronze-brown. A fine, cottony webbing on the underside of a leaf, clearly visible with a magnifying glass, is proof positive of the presence of mites.

As with aphids, the best control is a strong jet of water, but because the mites are on the undersides of leaves it's more difficult to get at them without drenching the surrounding area, including yourself. Insecticidal soap will also work but the same drawback applies. Mites hate water, so the more moist you can keep the immediate environment the better. (Catch 22 - moisture creates the perfect conditions for diseases like black spot.)

Whitefly and Leafhopper

The first sign of a whitefly infestation is a white speckling on leaves. When you turn a leaf over, you will see a scattering of tiny white insects, almost like little specks of lint, which are sucking the juices out of the leaves. When only a few leaves are affected, it is easy to remove them or squish the culprits. If the problem is more widespread, a spray of one teaspoon of pure soap liquid detergent in one litre (U.S. quart) of water should solve the problem. Be sure to direct the spray under the leaves as it only works on contact. Unfortunately, it will also kill the good bugs, such as ladybugs, so try to avoid these little creatures if possible. Do not increase the proportion of detergent and don't spray in hot sunshine, as either risks burning the leaves.

Leafhoppers cause the same kind of damage as whitefly, and look like larger, greener versions of them. The same spray will account for them, although they are true to their name and don't always sit still for the treatment.

Rose Slug

Occasionally a rose will become infested with little greenish-white worms, which are the larvae of the sawfly. Within a few days, they can skeletonize the leaves of a rose almost to the

point of defoliation. They are not caterpillars and so are impervious to the usual controls for these.

Insecticidal soaps will kill them but must actually make contact to do so, which means persistent spraying over several days. The best time to do this is early evening when the little beasts are most active and more likely to be on the upper surfaces of the leaves. If you choose a soap product which also contains pyrethrin (a derivative from the pyrethrum daisy), you will have better success as the pyrethrin residues are effective for several days. Be aware, however, that pure pyrethrin has quite a high toxicity rating.

It is vital to clean up leaf litter and twigs from under affected bushes several times a season to eliminate the pupae of the sawfly and so interrupt its life cycle. Shallow hoeing of the soil on a regular basis and laying down a thick mulch early in the year also threaten the survival of the pupae.

Caterpillars

True caterpillars are seldom a problem on roses and can usually be removed by hand. In the event that you do get an infestation of them, and are sure they are not rose slugs, the safest control is a spray of Bt. (Bacillus thuringiensis) or thuricide, which is a biological predator.

Thrips

When a rose bud opens unevenly or appears chewed and brown around the edges, the cause is usually thrips - minute insects which have invaded the bud while it was still tightly closed. This makes them difficult to deal with as the damage is almost always done by the time it is noticeable.

Pale-coloured roses are particularly susceptible. Cut off and destroy affected blooms. If this doesn't solve the problem, the only recourse is to use a commercial product. There is some hope that new products containing neem oil (derived from a tree in India) will be both effective and environmentally benign.

Rose Midge

This tends to be a serious problem only in gardens which have a lot of roses, and then only in certain years. The culprit is a tiny insect which lays its eggs in the growing tips of rosebushes. On hatching, the midge eats the tissue around it, resulting in a tiny, blackened end to a stem and no flower bud. In a bad year, infected plants will have no flowers at all. Once again, remedies are hampered by the fact that the damage is done by the time it is visible. Cutting back to a lower leaf gives you some prospect of a later flower from that point, and will, if you are very lucky, remove a still-resident midge, but the only feasible time to attack this pest with some hope of success is in spring while it is pupating in the soil below. Until recently, diazinon crystals were the one sure-fire treatment, both sprinkled over the soil and later sprayed in solution over the bushes. Unfortunately, diazinon is also toxic to earthworms and fish, and long lasting in the water table. I prefer not to use it. New biological products arriving on the market promise a less toxic option by introducing nematodes which feed on the midge pupae.

Three other garden occupants have some impact on roses, but each has more good points than bad. I mention them here more so that you can identify them as the cause of certain kinds of damage than for any other reason.

Spiders

Not really pests, in the sense that they probably control more damage than they inflict, spiders nevertheless use leaves for various purposes, including as a wrap for food storage. Irregular chunks bitten out of leaves are the result. If this bothers you, remove the perpetrator whom you'll probably find nearby.

Leafcutter Bees

Where spiders remove jagged portions of leaves, the leafcutter bee chews a neat semicircle out of the leaf edge. It particularly likes roses with fragrant foliage, such as those descended from Rosa eglanteria. The small bee is hard to spot and even harder to get rid of. But why should you want to? In return for the leaf material, which it uses to make a nest, this little denizen of the garden is an excellent pollinator.

Rose Gall Wasps

Occasionally a rose, usually a species like Rosa canina, will develop round, hairy balls on the stems, like tufts of tangled yarn. The English call them "Robin's Pincushion". These galls, which begin pale green or red and turn brown as they age, are caused by a small wasp that injects a substance into the tissue of the rose to produce this unnatural growth. The wasp then lays its eggs inside the gall, and if you tear one apart, you will often find the little white grubs that subsequently develop. Depending on your point of view, they are a curiosity worth keeping, or an unsightly blight that should be cut off. I leave them until spring for two reasons: firstly, like all wasps, this one is both a pollinator and a predator on other less welcome insects; secondly, I have noticed that in the hardest weeks of winter, the rose in my garden infested with these galls is alive with black-capped chickadees, intent on devouring whatever life form remains inside the now bedraggled tufts.

Secondary Pests

By secondary pests, I mean ones which don't attack roses per se, but cause potential harm in the process of going about their daily business. Moles, birds, cats and dogs fall into this category.

Moles

The good news is that moles are attracted to fertile soil; the bad news is that if one tunnels under a newly planted rose, the roots are dislodged just as they are trying to get a grip on the soil and, in the worst cases, are left hanging in the air pocket of the tunnel. Moles are carnivores, and freshly turned soil attracts them because it also attracts one of their dietary staples - worms. Bonemeal also seems to be a draw card, so if you have a problem with moles, you might want to leave it out of your planting mix: sprinkle it on top instead.

Some people advocate burying empty glass bottles around the new plant, with the tops angled so that wind blows across them. The theory is that moles don't like the sound vibrations. Other suggestions include burying the contents of the cat litter tray in the surrounding soil, and dropping moth balls, or (very poisonous!) castor beans into the tunnels. I haven't noticed positive effects myself.

The only guaranteed method to eliminate a mole is by using a scissor trap, following the directions on the box. The problem is that moles are territorial, and when a territory becomes vacant because a mole has been trapped, another soon moves in.

If the problem is severe in your area, try lining your planting hole with a fibre pot which has had the bottom removed. After a few months, when the rose is established, you can gently loosen and pull out this ring. Use a large size - at least a four-gallon pot.

Dogs and Cats

It seems that everyone has stories of either dogs fouling the lawn or garden beds, or cats scratching up the soil for a similar purpose. There are commercial repellents available, but they seem to have a limited duration, and they don't help out the organic gardener.

Almost as effective, and free, are coffee grounds from your morning or evening brew. Sprinkle them as thickly as you can on the area favoured by your own or your neighbour's pet. I like to save up a week's supply and then cover a considerable area. It's not foolproof, mind you - there will still be evidence of the occasional transgression - but in my experience, it does seriously reduce the popularity of the site, while looking good (like top-quality topsoil), and even fertilizing, if you stretch a point, by contributing a fractional amount of nitrogen to the soil.

Deer

Deer are very partial to roses and many a would-be rose grower has given up in the face of their depredations. Protective netting or fencing is the usual solution. If you plant a rambler rose and give it two or three years of protection, it should be too tough and thorny to be palatable, although the new shoots might get a regular pruning! This has been my experience with a number of vigorous ramblers which hang over a boundary fence within nibbling distance of our sheep; the sheep do a little tasting of the young foliage, but not enough to seriously interfere with the plants.

The other option, which I put forward tentatively on the strength of some promising but as yet too limited personal research, is to consider growing moss roses. I have given specimens of this class of roses to gardeners in deer country, and initial reports confirm that they have been passed over without damage. Presumably, the reason is the pungent nature of the sticky moss which covers the stems and buds of these roses. Moss roses come in the usual Old Garden Rose range of

colours - white and all shades of pink to deep crimson, and if grown on their own roots, most will gradually form impenetrable thickets up to 1.2 m. (4 ft.) high. A few, such as candy pink 'Salet', or pearly white 'Alfred de Dalmas' even have a second flush of bloom, but they sometimes sacrifice growth in favour of flowers. A row of a more vigorous variety, such as 'William Lobb' (q.v.) or the crimson-velvet 'Nuits de Young', might eventually form a barrier high and wide enough to protect more than itself from the deer.

NOTES

NOTES

8 TROUBLESHOOTING

Most of the problems faced by roses have to do with circumstances dealt with in preceding chapters on Care and Maintenance and Pest Control, but there are occasions when a plant fails to flourish that are not explained away by any of the obvious circumstances. The following checklist reviews a few of the more unusual threats to an otherwise healthy rose and suggests some additional possibilities to consider.

Site

Does the plant get at least 6 hours of sunshine in an average day? Although some of the vigorous ramblers and shrubs will make do with less than this, even they will not flower well until their canes reach into more sun.

Is the plant in a dry part of the garden - under an overhang perhaps, or competing unsuccessfully with tree roots for moisture?

Conversely, is the location poorly drained? Roses like a lot of water, but they don't like to sit in it. A raised bed is the best solution to a site which does not drain easily, and is easier to accomplish than the alternative of excavating deeply and putting down a gravel base.

Is the plant too close to the house foundation or to a fresh concrete driveway? Salts leaching from concrete or stucco, especially if the construction is recent, can make a rose decidedly unhappy.

Are other plants crowding the rose? Roses, especially modern hybrids, don't like to share, and even vigorous Old Garden Roses need a couple of years to get established before they can compete. Roses don't even share well with other roses - make sure that you have left enough space between bushes (see Chapter on planting).

Did you remove an older rose to provide a space to plant the new one? If so, your replacement is probably suffering from 'Specific Replant Disease", a condition peculiar to the rose family. The cause of this problem is not confirmed, but current research suggests that roses infect the soil around them with a substance toxic to other roses (although not to any other types of plant.) The only solution is to replace the soil in which you plant the new rose, or move the rose elsewhere and plant a perennial or a different kind of shrub in that spot.

Human Error

Was there something in the planting mix that is affecting the rose? Peat moss is a common soil conditioner often used in planting mixes, but it must be soaked thoroughly in water beforehand (warm water makes this task easier). If not, it can remain dry even after heavy watering, and so the rose will not get enough moisture. Sawdust creates the same problem and, worse, it strips nitrogen from the soil in order to decompose. If you are determined to use it, wet it down and add extra nitrogen in some form, such as alfalfa pellets or fish fertilizer. Granular nitrogen and fresh manure will burn tender roots and should only be used as a top dressing, never in the planting mix. Mushroom manure, once thought of as the wonder food, may contain salts that roses react badly to, and should always be used sparingly at any time and certainly not at planting time.

Did the plants dry out at any time before planting? Sometimes this happens in the nursery and the results don't show until after you have brought your purchase home. Roses ordered through the mail may dry out en route to you. Although most companies pack them carefully to avoid this likelihood, the package may have spent too long in a mailroom, or you may have neglected to unpack and soak the roses overnight before planting.

Did the bushes get enough water throughout the year? One deep watering a week is much more beneficial than several light sprinklings, which only reach the surface roots.

Are they suffering from spray damage? Some roses, especially Rugosa varieties, not only don't need spraying, they actively resent it. Leaves will speckle, wither or droop, but given time the rose will recover. A worse situation is caused by indiscriminate spraying of weed-killer onto nearby grass, or

using sprayed grass as a mulch. If the leaves on your roses are thin and twisted like wood shavings, this is where the problem lies. Once the damage is done, you can only hope that the rose will survive it, but it may never wholly recover. In future, make sure you treat your grass on a windless day as fine spray can drift amazing distances in even a slight breeze. If you haven't used a weed killer, consider whether your neighbour might have, and ask to be informed beforehand so that you can put up some plastic sheeting as a barrier at the time. Do not put grass clippings into your compost pile until the fourth cut after a dose of weed killer.

Did you use the appropriate pruning technique? Advice on pruning is often confined to Hybrid Tea and Floribunda roses because these modern varieties dominate the retail trade. These roses should be pruned hard when planted, and then no long flower stems should be cut during their first year. Once-blooming shrub roses, if pruned at all, should be trimmed after they finish blooming in summer, as they flower on old wood. Spring pruning deprives them of the coming season's bloom. Climbers flower on laterals, the stems branching off the main canes. The main canes should only be pruned back lightly to a strong lateral; otherwise, the plant's energy will then go into making more new canes or extending a cut one all over again, rather than into producing flower-bearing laterals.

Are your expectations too great? Some roses, particularly climbers and Old Garden Roses, do not flower in their first year. If the rose is being asked to climb a tree, it may not flower until it reaches its full height. 'Kiftsgate', a popular giant of a rose, is notorious for taking up to four years to bloom.

Roses imported from England are usually grafted onto Rosa laxa, an understock that produces thinner canes and grows more slowly than the understocks used in North America. These imports often take three years to reach maturity. Similarly, roses grown on their own roots are slower to mature, and often need an extra year before they flower.

Other Factors

Winter Kill

Frost damage in winter can be the death of a rose. Some varieties, such as those with Rosa chinensis genes in them like the old-fashioned Tea roses and most of the Noisette climbers, are tender, even in our moderate winter.

All grafted roses are particularly vulnerable at the point where the graft was made (the bud union). To ensure that they are protected, cover the base of the rose with straw or leaf mould or extra soil from elsewhere in the garden (not scraped up from around the plant which only exposes the fragile feeder roots to the cold.) Do this in November and remove it around the end of February.

Even hardy roses can suffer the effects of frost and icy winds: cut back all canes that look shrivelled or black until you come to fresh pith. This may mean cutting off all visible growth, but in most cases new buds will sprout from the base in a few weeks.

Animals

As mentioned elsewhere, moles can undermine roses, especially newly-planted ones, leaving the roots dangling in their tunnels. Tread gently around the base of a plant to firm the soil back down again. This can escalate into full-scale war if the mole persists in reopening the same routes. Deterrents such as cat hair, moth balls, castor beans, even used kitty litter placed in the holes, have their advocates but each has just as many scoffers. Trapping the culprit is a short-term solution, but moles are territorial and another usually moves in as soon as the word gets out. In my own garden, I trapped seventeen moles in two months, but the evidence of their activity is just as obvious as before. There's a fortune waiting to be made by whoever comes up with a practical, long-term solution; meanwhile the only consolation is that a thriving mole population is an indication of excellent soil.

In rural areas, voles and field mice also travel through mole tunnels and nibble on young roots as they pass, especially in winter. Acquiring a cat helps.

Wind

Wind is a worse enemy of roses than cold. It desiccates the canes of climbing roses, rubs canes together creating lesions where disease or frost can enter, and rocks large bushes loose in the soil, leaving hollows that can fill with freezing water. Tie canes securely to wall or trellis, and wrap tender climbers with protective material before winter gales are forecast. Trim large bushes back and mound up soil around their bases to minimize wind-rock.

Age

Age is sometimes forgotten as a factor in the vigour of roses. While shrub roses and climbers can live for many years, often longer than their human nurturers, most Hybrid Teas and Floribundas have a relatively short lifespan - anywhere from 5 to perhaps no more than 10 years. If grandma's favourite rosebush is beginning to fail in spite of your loving care, it may well be that it has reached the end of its productive life.

Climate

If, in spite of all your precautions, a rose continues to sulk in your garden, perhaps it was not a good rose for growing in this climate. Many roses that are rated highly in surveys receive much of their acclaim from gardeners who enjoy warmer, sunnier conditions all year than we do, or who simply have a longer or hotter summer. The moist air that makes our forests so lush weighs down heavy blooms on slender necks, and glues fragile petals together so that emerging blooms become balls of brown mush. Roses with these characteristics are doomed to disappoint. This brings us all the way back to Ch. 1 and the importance of choosing a suitable rose.

NOTES

SOURCES
for Roses recommended in this book

British Columbia

Earthrise Garden Store

2954 West 4th Avenue, Vancouver. V6K 1R4
Phone: (604) 736-8404
Owner Michael Luco will seek out and order hard-to-find roses.

Killara Farm

21733 - 8th Avenue, Langley. V2Z 1R4
Phone/Fax: (604) 532-9831
Small cottage nursery of Old Garden Roses, ramblers and some modern shrub roses, all grown on their own roots. By appointment only.
Catalogue $2.00

Select Roses

22771 - 38th Avenue, Langley. V3A 6H5
Phone: (604) 530-5786
Wide range of Hybrid Tea, Floribunda, shrub, David Austin, miniature and climbing roses. Open mid-March to end September, closed Tuesdays. Display garden.

Old Rose Nursery

1020 Central Rd., Hornby Island. V0R 1Z0
Phone: (250) 335-2603
Fax: (250) 335-2602
e-mail: oldrose@mars.ark.ca
Large selection of Old Garden Roses, ramblers, climbers and shrubs, all on own roots. Display garden. Direct shipping.
Catalogue $ 2.00

The Fragrant Rose Company

R.R. #1, Site 19, C8, Fanny Bay. V0R 1W0
Phone: 1-888-606-ROSE (7673)
Harkness roses imported from England. Catalogue $2.00

Washington

Christianson's Nursery

1578 Best Rd., Mt. Vernon. WA.
Phone: (360) 466-3821
Extensive collection. Display garden

Cottage Creek Nursery

13300 Avondale Rd. NE, Woodinville. WA. 98072
Phone: (425) 883-8252
500 varieties - list available on request. Offers seminars on rose care.

Valley Nursery

20882 Bond Rd. NE, Poulsbo. WA 98370
Phone (800) 597-2819 or (360) 779-3806

Oregon

Heirloom Old Garden Roses

24062 NE Riverside Drive, St. Paul. OR 97137
Phone: (503) 538-1576
Old Garden Roses, shrubs, climbers and ramblers on their own roots. Catalogue: $5.00

Mail Order Sources

Carl Pallek & Son Nurseries

Box 137, Virgil, Ontario. L0S 1T0.
Phone: (416) 468-7262 Free catalogue on request.

Hortico

Phone: (905) 689-6984 or 689-3002
Fax: (905) 689-6566 (24 hrs)
24-hr service for orders: 9(05) 689-9323
Extensive collection of all types of roses - 700 varieties, most grafted onto multiflora understock. Minimum order of 5 roses. Will ship to U.S.A. Catalogue $3.00

Pickering Nurseries

670 Kingston Rd.
Pickering, Ontario. LiV 1A6
Phone: (416) 839-2111 Fax: (416) 839-4807
Good collection of all types of roses, especially Old Garden
Roses, all grafted onto an understock. Minimum order of 3 roses.
Will ship to U.S.A.
Catalogue $ 4.00

PUBLIC ROSE GARDENS TO VISIT
in British Columbia & Washington State

Vancouver
Stanley Park Rose Garden,
 west end of Georgia St., Vancouver, BC
Coquitlam Centre Rose Garden,
 Poirier , Coquitlam BC
Burnaby Mountain Rose Garden,
 Burnaby BC
Park and Tilford Garden,
 North Vancouver BC
University of British Columbia Rose Garden,
 north end of Main Mall.

Victoria
Butchart Gardens
 800 Benvenuto Ave., Brentwood Bay, BC V8M 1J8
 Tel; (250) 652-5256
Point Ellice House
 2616 Pleasant Ave., Victoria, BC V8T 4VS
 Tel: (250) 380-6506

Washington State
Centennial Rose Garden,
 at Schmidt Mansion, Tumwater, WA
Point Defiance Rose Garden,
 5400 N. Pearl St. Tacoma, WA
Woodland Park Rose Garden,
 500 Phinney Ave. N., Seattle, WA

ROSE SOCIETIES

British Columbia

Vancouver Rose Society
c/o 7084 Blenheim St.,
Vancouver, B.C. V6N 1R9

Fraser Pacific Rose Society
c/o 30210 Keystone Ave.,
Mission, B.C. V2V 4H9

Peninsular Rose Society
c/o 1025 Greenridge Cres.
Victoria, B.C. V8X 3B8

United States

Seattle Rose Society
c/o 17130 SR 9 East,
Snohomish, WA. 98296

Portland Rose Society
P.O. Box 515,
Portland, Oregon. 97207-0515

Olympia Rose Society
c/o 3504 Southampton Ct. SE,
Olympia WA. 98501

Tacoma Rose Society
c/o 2132 Bridgeport Way W.,
Tacoma, WA 98466

Tri-City Rose Society
c/o 2600 Harris Ave.,
Richland. WA 99352

BIBLIOGRAPHY

Austin, David
Shrub Roses and Climbing Roses, Antique Collectors' Club, 1993

Beales, Peter
Classic Roses, Henry Holt & Co.,1985, 2nd ed. 1997.
Twentieth Century Roses, Harper & Row, 1988

D. G. Hessayon
The Rose Expert, 3rd. ed., pbi Publications, 1988

McFarland, J. Horace
Roses of the World in Color, Houghton MifflinCo., 1938

Phillips, Roger & Rix, Martyn
Roses, Random House, 1988

Thomas, Graham Stuart
The Graham Stuart Thomas Rose Book, Timber Press, 1994

American Rose,
 journal of The American Rose Society

The Rose,
 journal of The Royal National Rose Society

The Rosebank Letter,
 Rosecom, London, Ont., Canada

The Rose Bed,
 journal of The Vancouver Rose Society,
 Vancouver, B.C.,Canada

The Photographs

The majority of the pictures in this book were taken by the author. Other photographs were kindly loaned by the following:

Michael Kluckner:
Loving Memory, Electron, Ingrid Bergman, Tabris, Sexy Rexy, Playboy, Lavaglow, Fellowship, Blanc Double de Coubert, Stanwell Perpetual, Celestial, Charles de Mills, Rosa Mundi, Complicata, Fantin Latour, Ghislaine de Féligonde, François Juranville, Mme. Alfred Carrière, Rosemary Harkness, Fru Dagmar Hastrup, Rosa rugosa.

Alister Browne:
Paradise, Elina, Chicago Peace, Iceberg, Double Delight.

Brad Jalbert:
Bonica, Abraham Darby, Opening Act, Warm Welcome, Fragrant Cloud, Sandalwood, Green Ice, Leander.

George Mander:
Golden Beryl.

Acknowledgements

All I know about roses I learned in the years I have been a member of Vancouver Rose Society. I am indebted to Darlene Sanders for encouraging me to join. Over the years, many of the members have welcomed me to their gardens and shared their opinions on roses and rose growing with me. I am grateful to them all.

In particular, Janet Wood, C.D. Yeomans, Brenda Viney, Brad Jalbert, Jeff Wyckoff, Malcolm and Danielle Scott, Susan Pawlett and Joanne Baskerville were kind enough to review my list of roses and give me their comments. Brad Jalbert read the manuscript for content, suggested improvements and was always willing to share his considerable knowledge with me. Michael Kluckner, Brad Jalbert, Alister Browne and George Mander generously lent me photographs from their collections.

Moira Carlson, who grows beautiful roses and draws them even more beautifully, turned words into art.

At Steller Press, Sandra Hargreaves, Guy Chadsey and Colin Fuller had faith and fortitude.

My husband Michael read the manuscript for style, argued with me over syntax, tolerated my distractedness and bolstered my confidence. He also cut the grass.

INDEX

HYBRID TEAS (Large-flowered Roses)

FLORIBUNDAS (Cluster-flowered Roses)

SHRUB ROSES

David Austin's English Roses

CLIMBERS

RAMBLERS

OLD GARDEN ROSES

MINIATURE ROSES

NOTES